Wisconsin Barn Quilts
Coloring Book One

John H. Lettau

Spinning Star

Mystery Square

Southern Star

Barn Quilts of Shawano County Wisconsin

Cover Quilts

Starry Path...Sara's Star...Welcome Home
Nebraska Windmill...Autumn Leaves...Barn Raising
Hopscotch with Peruvian Horse
Hopscotch...Flaming Star

2016 copyright John H. Lettau & Shawna Lettau

Shawano County Wisconsin Barn Quilt Project

A drive through Shawano County is very colorful today because more than 300 brillant "quilt blocks," called barn quilts, are on display on barns throughout the county. Five barn quilts located in the county are displayed above...The Red Rooster, Gamma Ray Burst, Whirlygig, Circling Swallows & Sunflower.

The Shawano County Barn Quilt Project was started by Shawano writer/photographer Jim Leuenberger in 2010. In June 2010 Jim proposed the idea to local 4-H clubs as a possible club service project. Since then, several clubs have sponsored and painted barn quilts. And individual barn owners, businesses and individuals have supported the project through sponsoring a quilt and/or having a quilt put on their barn.

Shawano County Barn Quilt Project Objestives

1. To encourage the preservation of Shawano County's historic barns.
2. To promote tourism for Shawano County.
3. To provide an opportunity for groups like 4-H clubs, FFA chapters and others to sponsor and paint a barn quilt as a community service project.

What is a Barn Quilt?

A barn quilt is made by painting a quilt pattern on two 4' by 8' sheets of ¾ inch plywood then mounting them on a barn to form an eight foot square. Two coats of primer are applied to both sides of the boards plus the edges. After the pattern is drawn out, Frog (painters) tape is applied. Three coats of each color are applied, with each coat being allowed to dry overnight. After the quilt is finished, it is allowed to dry for at least two weeks before it is put upon a barn.

When some one wanted a quilt for their barn, they met with Leuenberger to pick out a pattern and the colors they wanted it painted in. Since January 2011, at least one barn quilt was put up in Shawano County every month for 52 months in a row.

Shawano County Barn Quilt Information

Books-Maps-Information-Tours

Shawano County Chamber of Commerce & Visitors Center
1632 South Main Street
Shawano, Wisconsin 54166
715-524-2139 805 235,8528 www.shawanocounty.com

Shawano County Wisconsin Barn Quilts Book One

All Hallows	Green Valley Rd	Pulaski
Hopscotch Peruvian Horse	Valley Rd	Shawano
Mystery Square	County Rd Q	Wittenberg
Lucky Clover	County Rd S	Pulaski
The Red Rooster	Landstad Rd	Bonduel
Farmer's Pride	Broadway Rd	Bonduel
Gamma Ray Burst	County Rd M	Shawano
Sara's Star	State Hwy 22	Clintonville
Crown of Thorns	Evergreen Rd	Shawano
Corn & Beans	State Hwy 117	Bonduel
Flaming Star	Waukechon Rd	Shawano
Indianapolis	Beech Dr	Pulaski
54-40 or Fight	Slab City Rd	Bonduel
Skyrocket	County Rd E	Cecil
Barn Raising	Maple Rd	Pulaski
Circling Swallows	State Hwy 160	Pulaski
Rising Star	County Rd N	Birnamwood
Hopscotch	State Hwy 29	Shawano
Patriotic Star	Broadway	Shawano
Starry Path	Main Laney Drive	Pulaski
Whirlygig	County Rd Q	Wittenberg
Evening's Last	Linke Rd	Tigerton
Twinkling Star	Ox Yoke Rd	Tigerton
Optical Illusion	Cloverleaf Lakes Rd	Shawano
Butterfly Stars	State Hwy 45	Tigerton
Welcome Home	Church Rd	Shawano
Nebraska Windmill	State Hwy 47	Bonduel
Road to Damascus	Old Dump Rd	Bonduel
Endless Ribbon	Brook Road	Shawano
All American Star	County Rd CC	Shawano
Spinning Star	Basswood Rd	Shawano
Pieced Tulips	Pine Road	Cecil
Eight Pointed Star	One Mile Rd	Shawano
LeMoyne	Belle Plaine Ave	Shawano
Star Within a Star	Curt Black Rd	Shawano
Sunflower	Locust Rd	Shawano
Saw Tooth Square	State Hwy 29	Shawano
Homeward Star	Broadway Rd	Bonduel
Pierced Star	Oakcrest Drive	Shawano
Electric Fan	State Hwy 29	Shawano
Flying Kites	North Branch Rd	Caroline
Merry Kite	County Rd M	Tigerton
Southern Star	Hazel Drive	Shawano
Four Patch with Pinwheel	County Rd V	Cecil
Hands All Around	Hirt Rd	Tigerton
Seesaw	Stony Hill Rd	Marion
Autumn Leaves	Grant Rd	Caroline
Twisted Star	Oak Ave	Shawano

Barn Quilt All Hallows
Shawano County Wisconsin Barn Quilts

Barn Located
Green Valley Rd
Pulaski, Wisconsin

Wisconsin Barn Quilt All Hallows

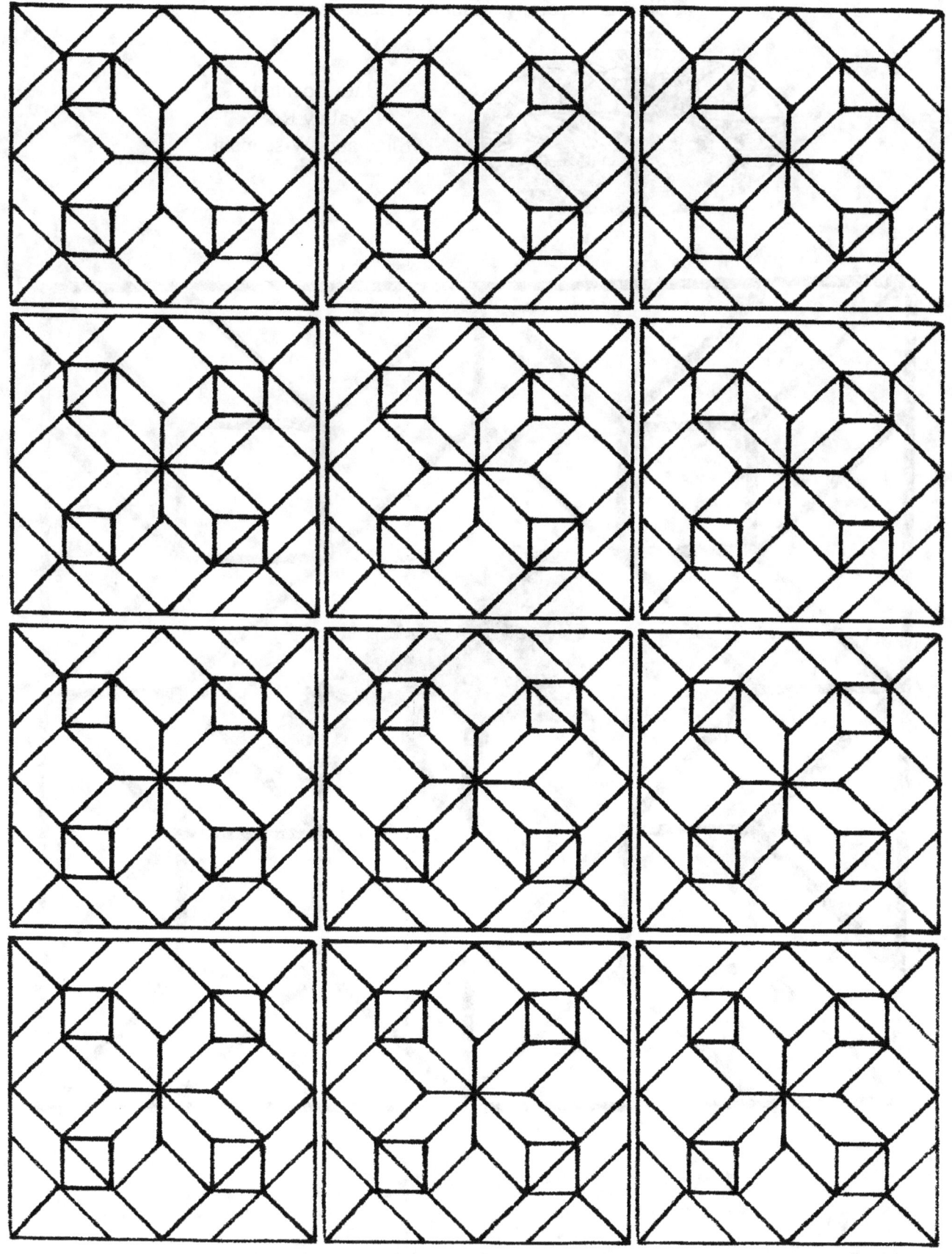

Barn Quilt Hopscotch Peruvian Horse
Shawano County Wisconsin Barn Quilts

Barn Located
Valley Rd
Shawano, Wisconsin

Wisconsin Barn Quilt Hopscotch Peruvian Horse

Barn Quilt Mystery Square
Shawano County Wisconsin Barn Quilts

Barn Located
County Rd Q
Wittenberg, Wisconsin

Wisconsin Barn Quilt Mystery Square

Barn Quilt Lucky Clover
Shawano County Wisconsin Barn Quilts

Barn Located
County Rd S
Pulaski, Wisconsin

Wisconsin Barn Quilt Lucky Clover

Barn Quilt The Red Rooster
Shawano County Wisconsin Barn Quilts

Barn Located
Landstad Rd
Bonduel, Wisconsin

Wisconsin Barn Quilt The Red Rooster

Barn Quilt Farmer's Pride
Shawano County Wisconsin Barn Quilts

Barn Located
Broadway Rd
Bonduel, Wisconsin

Wisconsin Barn Quilt Farmer's Pride

Barn Quilt Gama Ray Burst
Shawano County Wisconsin Barn Quilts

**Barn Located
County Road M
Shawano, Wisconsin**

Wisconsin Barn Quilt Gamma Ray Burst

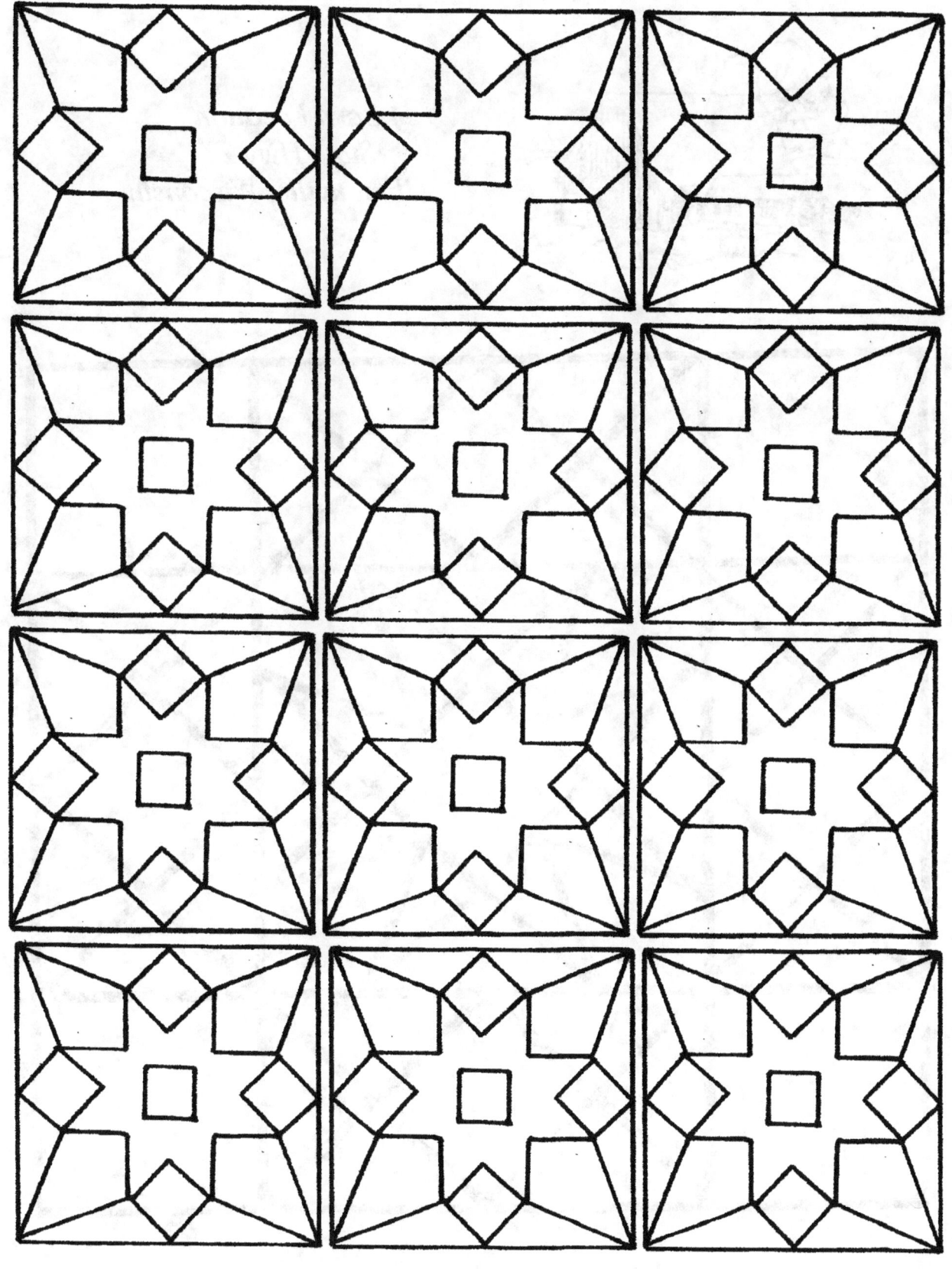

Barn Quilt Sara's Star
Shawano County Wisconsin Barn Quilts

Barn Location
State Hwy 22
Clintonville, Wisconsin

Wisconsin Barn Quilt Sara's Star

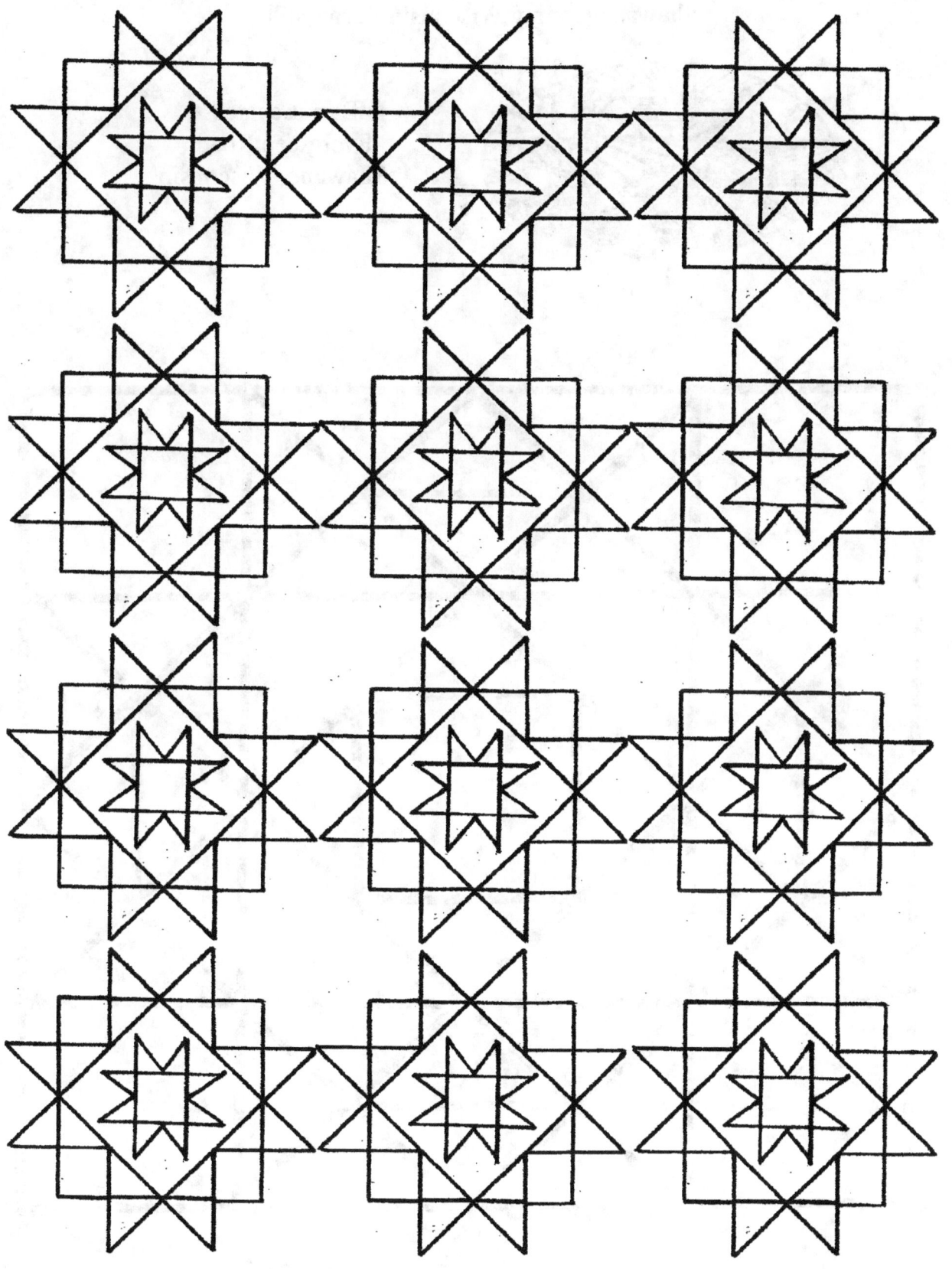

Barn Quilt Crown of Thorns
Shawano County Wisconsin Barn Quilts

Barn Located
Evergreen Road
Shawano, Wisconsin

Wisconsin Barn Quilt Crown of Thorns

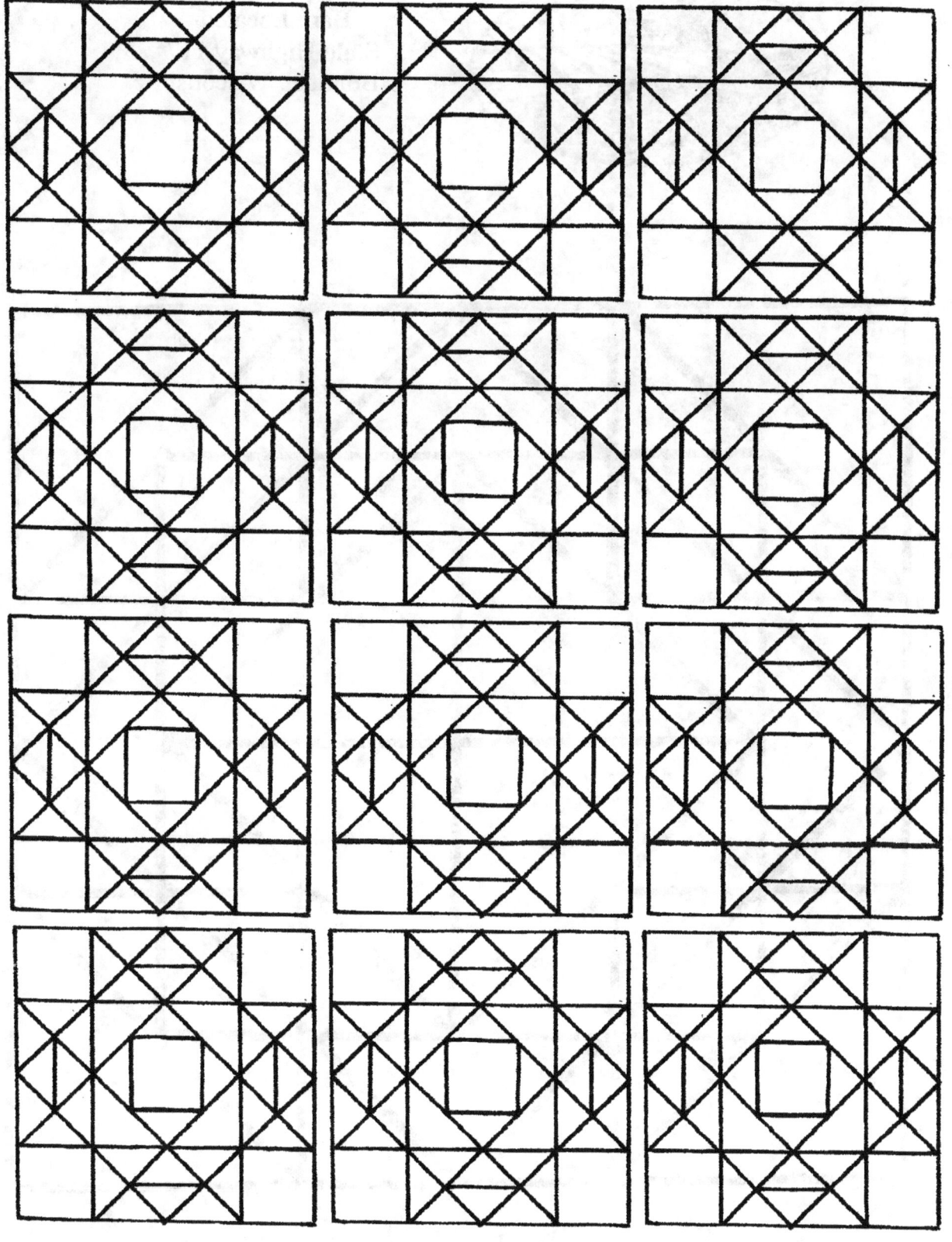

Barn Quilt Corn & Beans
Shawano County Wisconsin Barn Quilts

**Barn Located
State Highway 117
Bonduel, Wisconsin**

Wisconsin Barn Quilt Corn & Beans

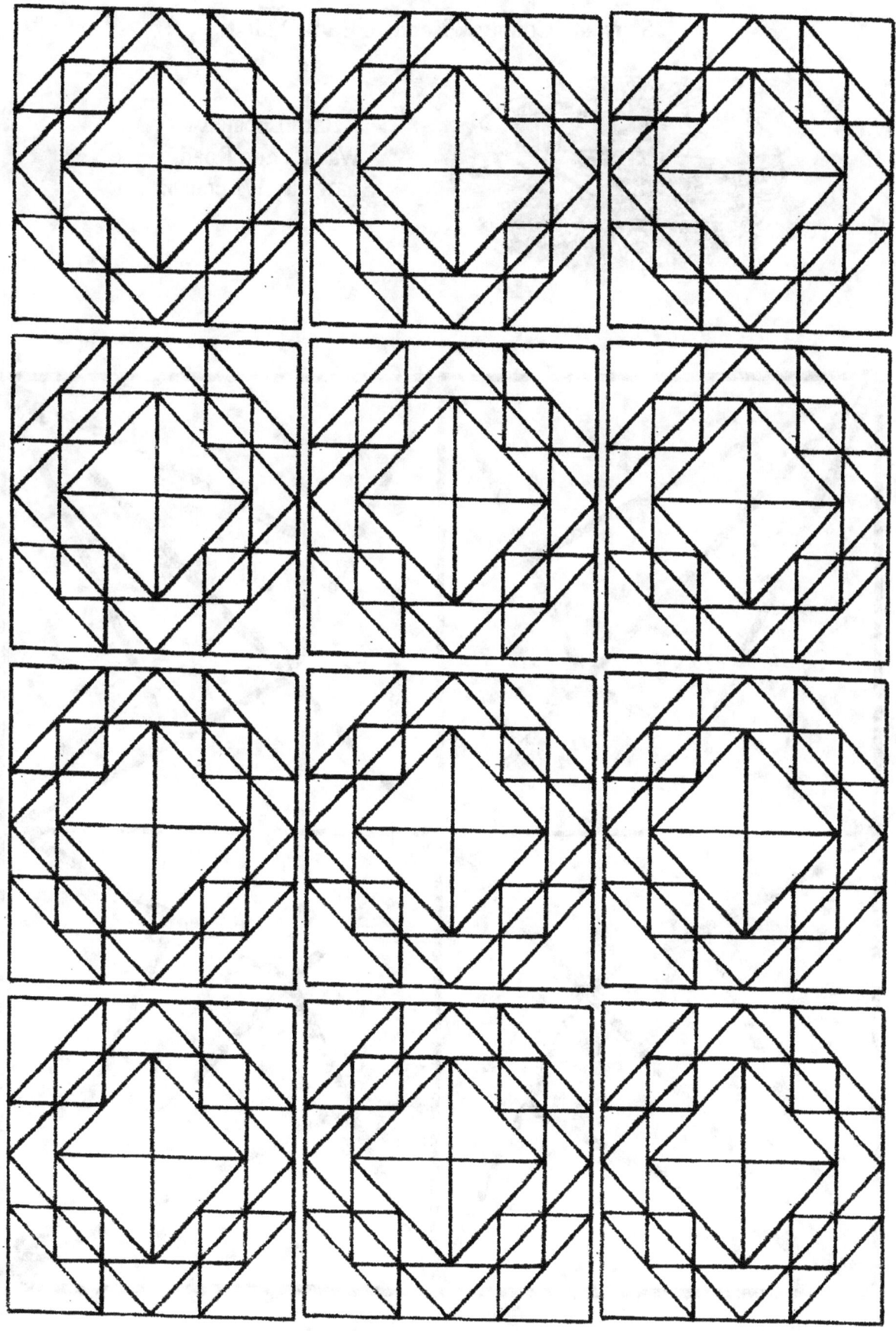

Barn Quilt Flaming Star
Shawano County Wisconsin Barn Quilts

Barn Located
Waukechon Road
Shawano, Wisconsin

Wisconsin Barn Quilt Flaming Star

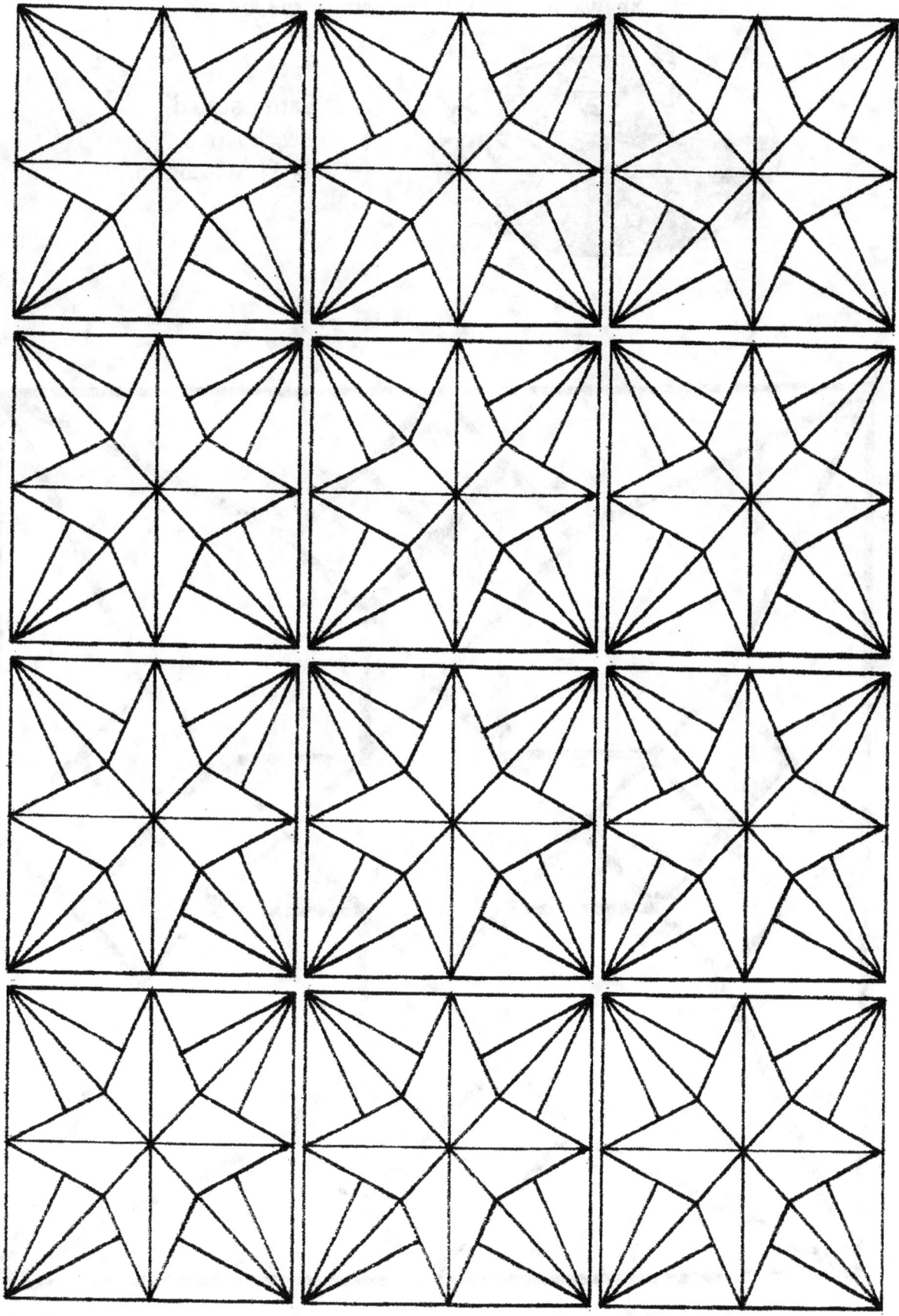

Barn Quilt Indianapolis
Shawano County Wisconsin Barn Quilts

Barn Located
Beech Drive
Pulaski, Wisconsin

Wisconsin Barn Quilt Indianapolis

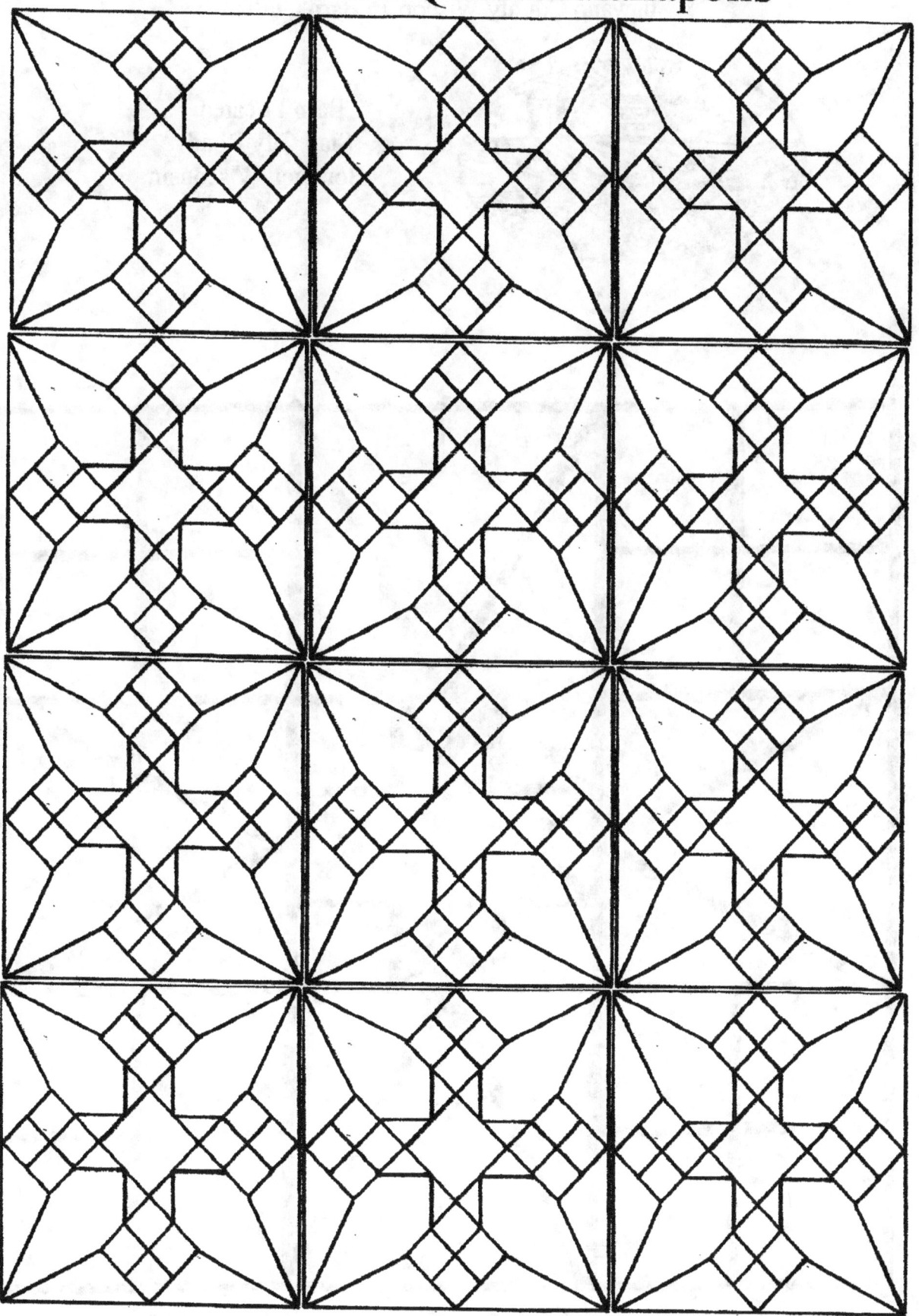

Barn Quilt 54-40 0r Fight
Shawano County Wisconsin Barn Quilts

Barn Located
Slab City Road
Bonduel, Wisconsin

Wisconsin Barn Quilt 54-40 or Fight

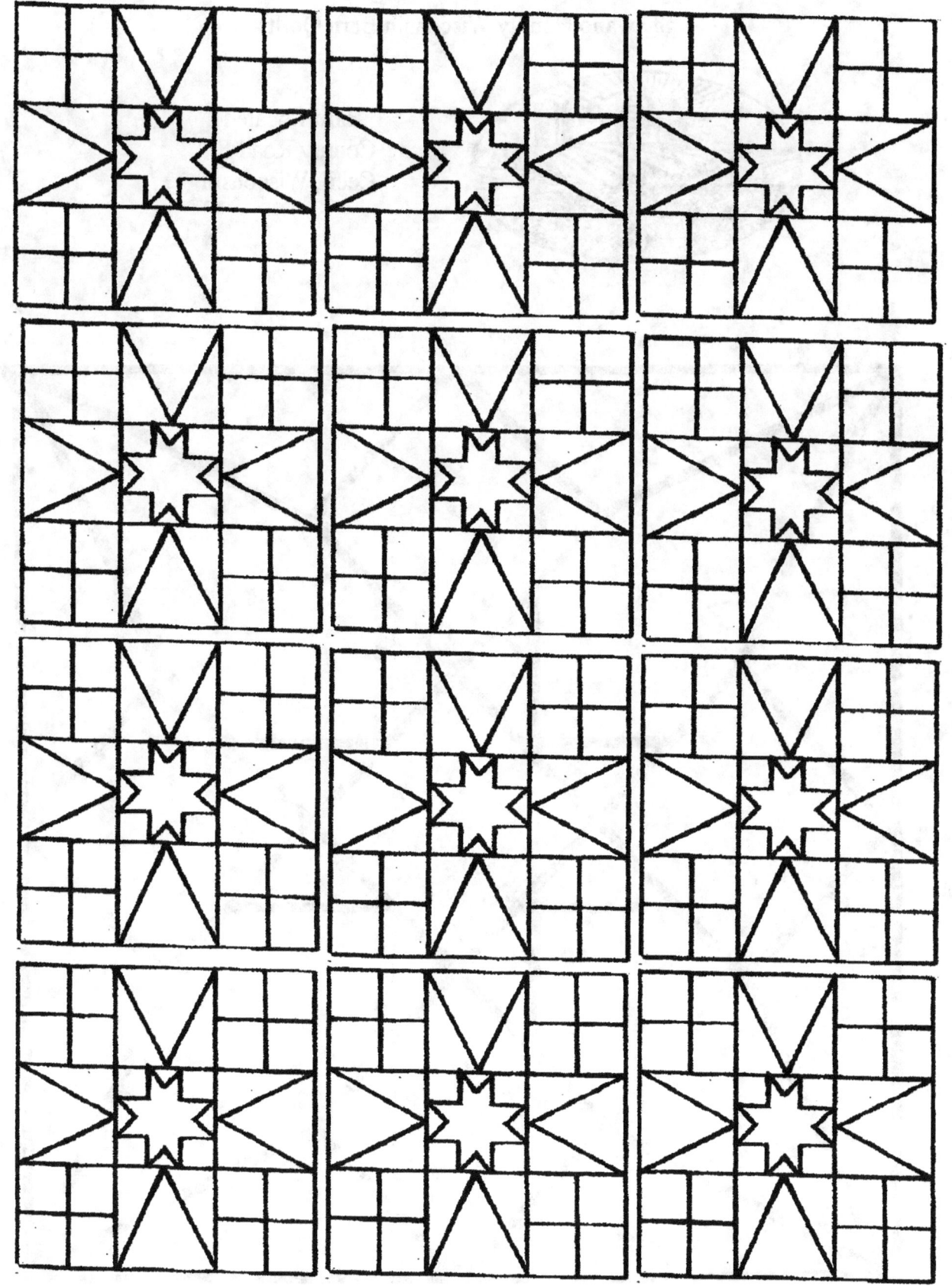

Barn Quilt Skyrocket
Shawano County Wisconsin Barn Quilts

Barn Located
County Road E
Cecil, Wisconsin

Wisconsin Barn Quilt Skyrocket

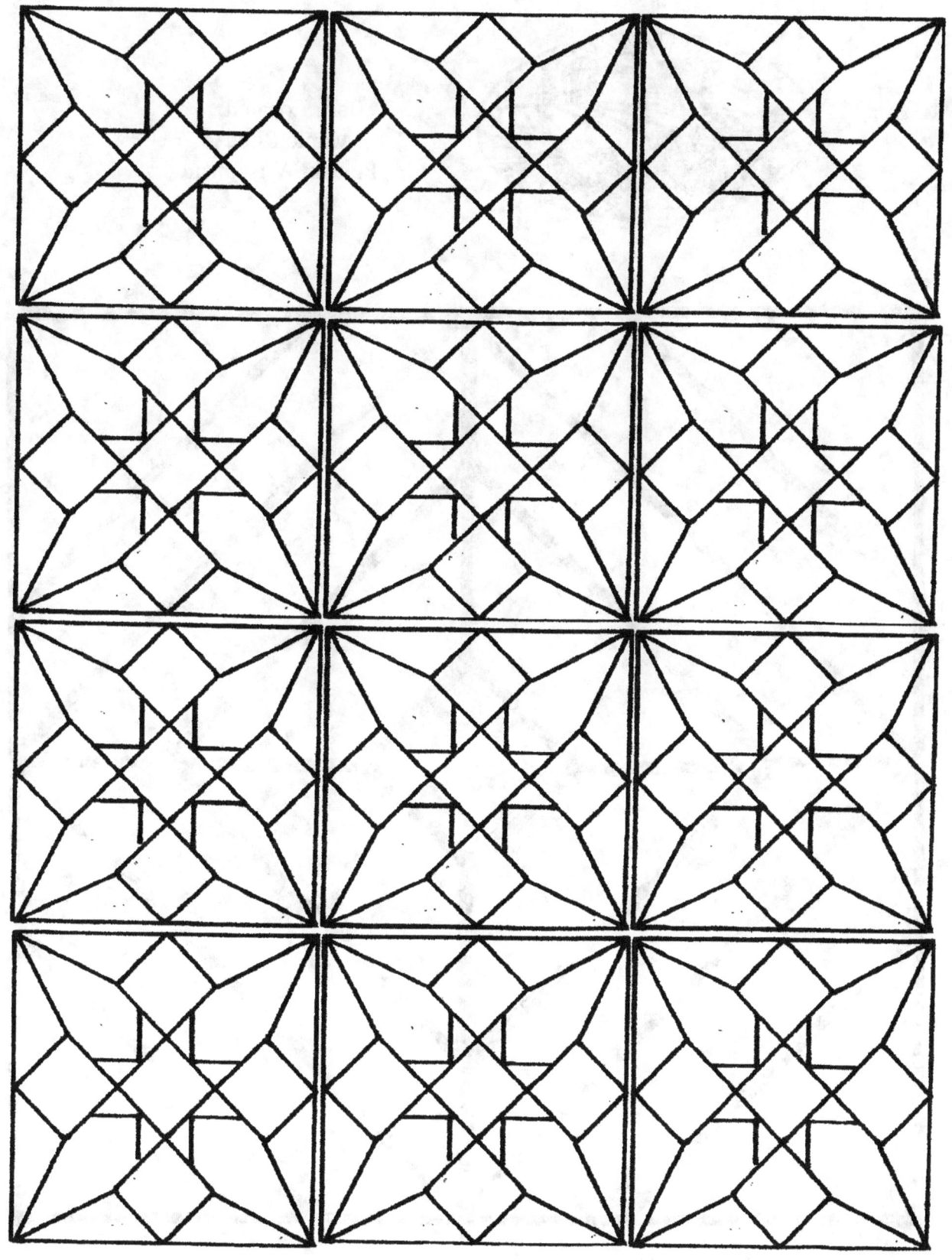

Barn Quilt Barn Raising
Shawano County Wisconsin Barn Quilts

Barn Located
Maple Road
Pulaski, Wisconsin

Wisconsin Barn Quilt Barn Raising

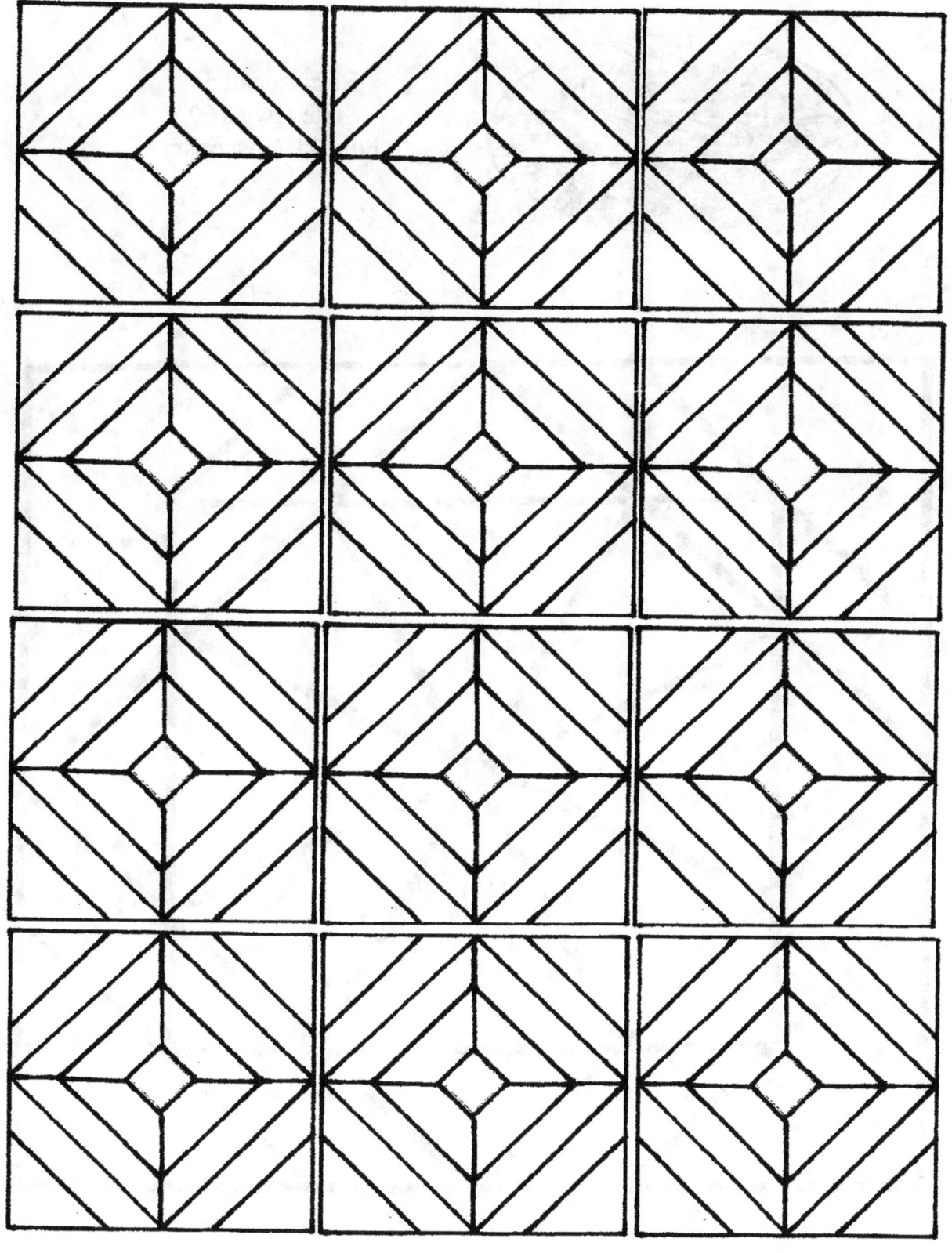

Barn Quilt Circling Swallows
Shawano County Wisconsin Barn Quilts

Barn Located
State Hwy 160
Pulaski, Wisconsin

Wisconsin Barn Quilt Circling Swallows

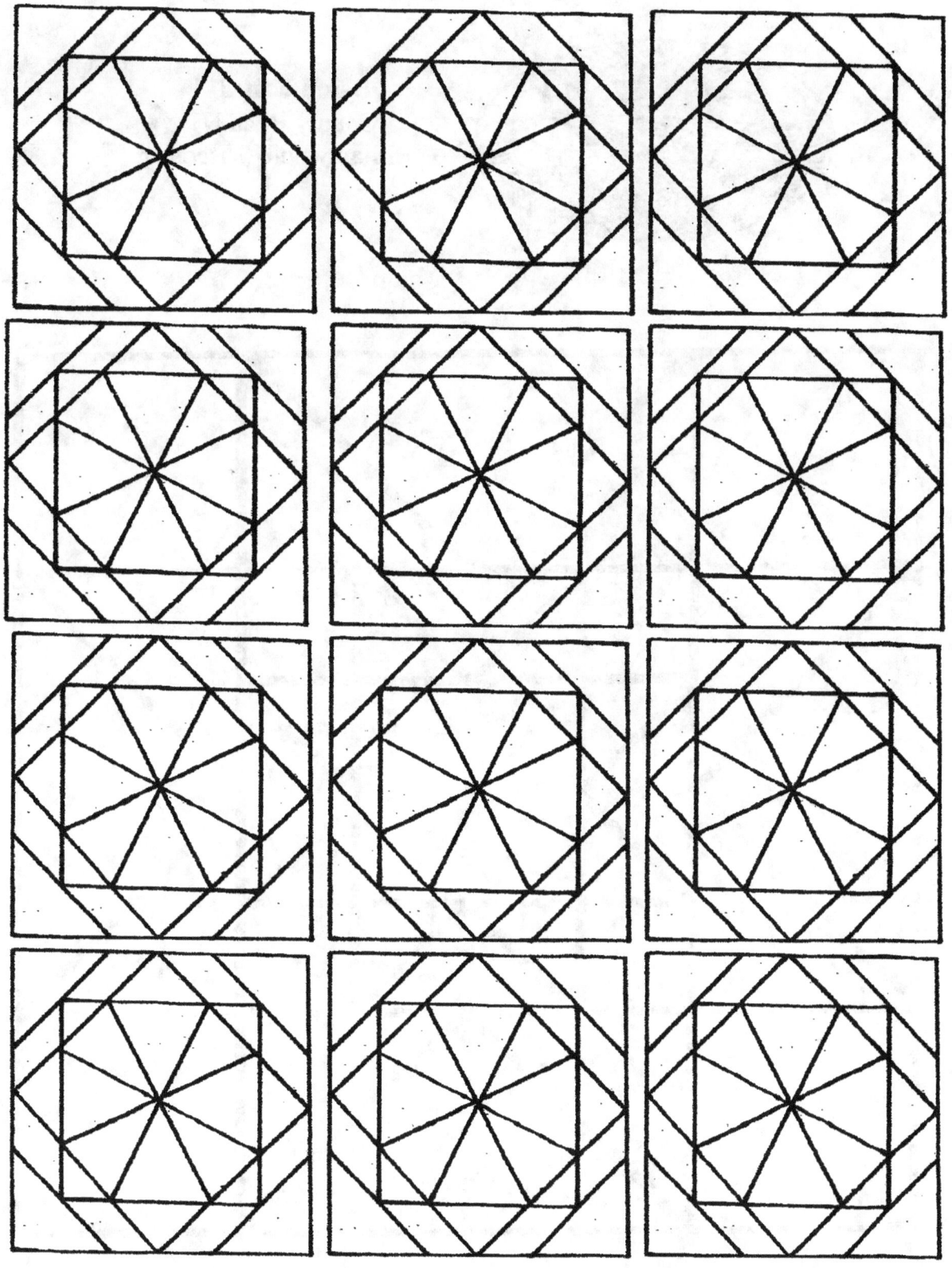

Barn Quilt Rising Star
Shawano County Wisconsin Barn Quilts

Barn Located
County Road N
Birnamwood, Wisconsin

Wisconsin Barn Quilt Rising Star

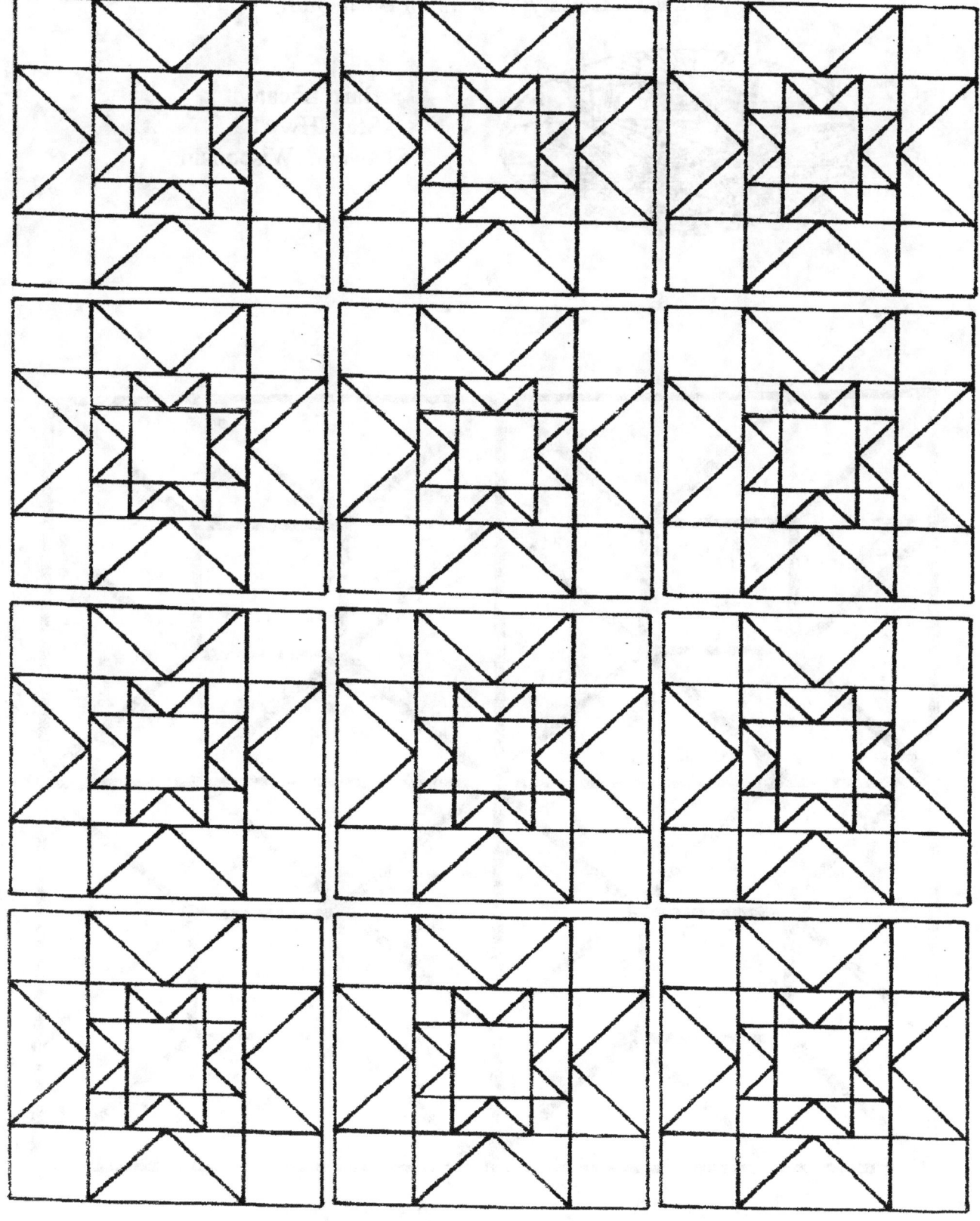

Barn Quilt Hopscotch
Shawano County Wisconsin Barn Quilts

**Barn Located
State Hwy 29
Shawano, Wisconsin**

Wisconsin Barn Quilt Hopscotch

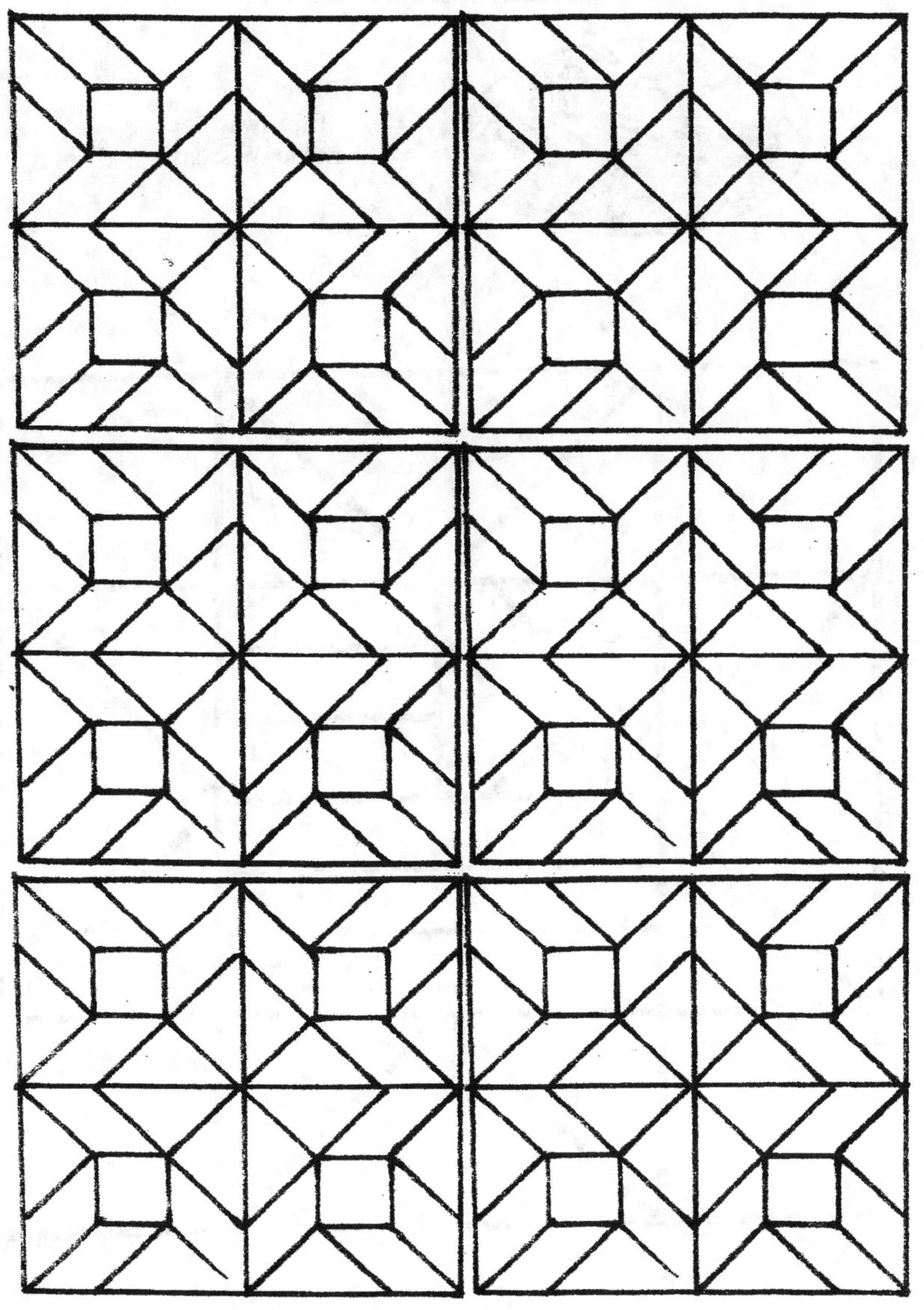

Barn Quilt Patriotic Star
Shawano County Wisconsin Barn Quilts

Barn Located
Broadway
Shawano, Wisconsin

Wisconsin Barn Quilt Patriotic Star

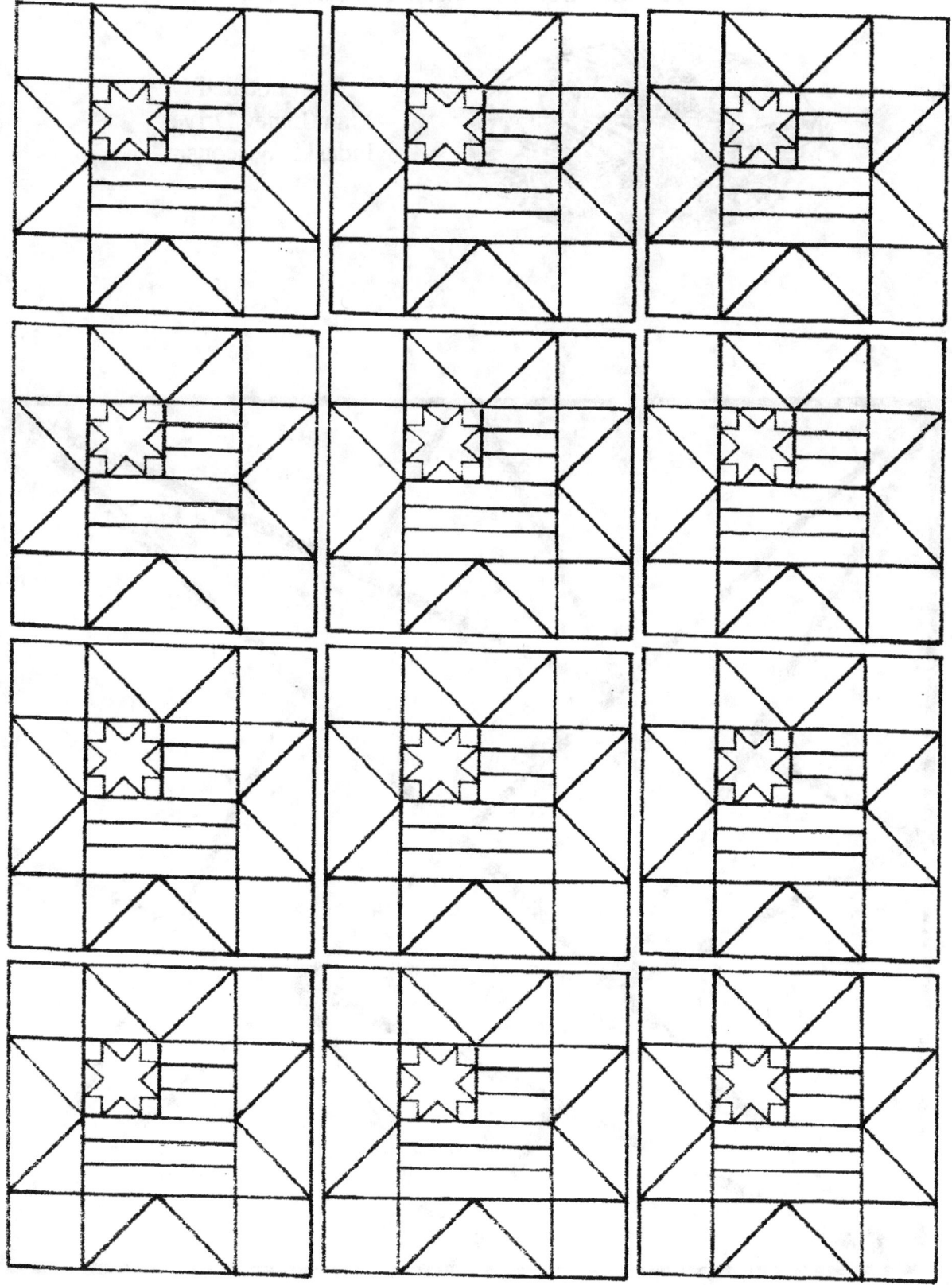

Barn Quilt Starry Path
Shawano County Wisconsin Barn Quilts

Barn Located
Main Laney Drive
Pulaski, Wisconsin

Wisconsin Barn Quilt Starry Path

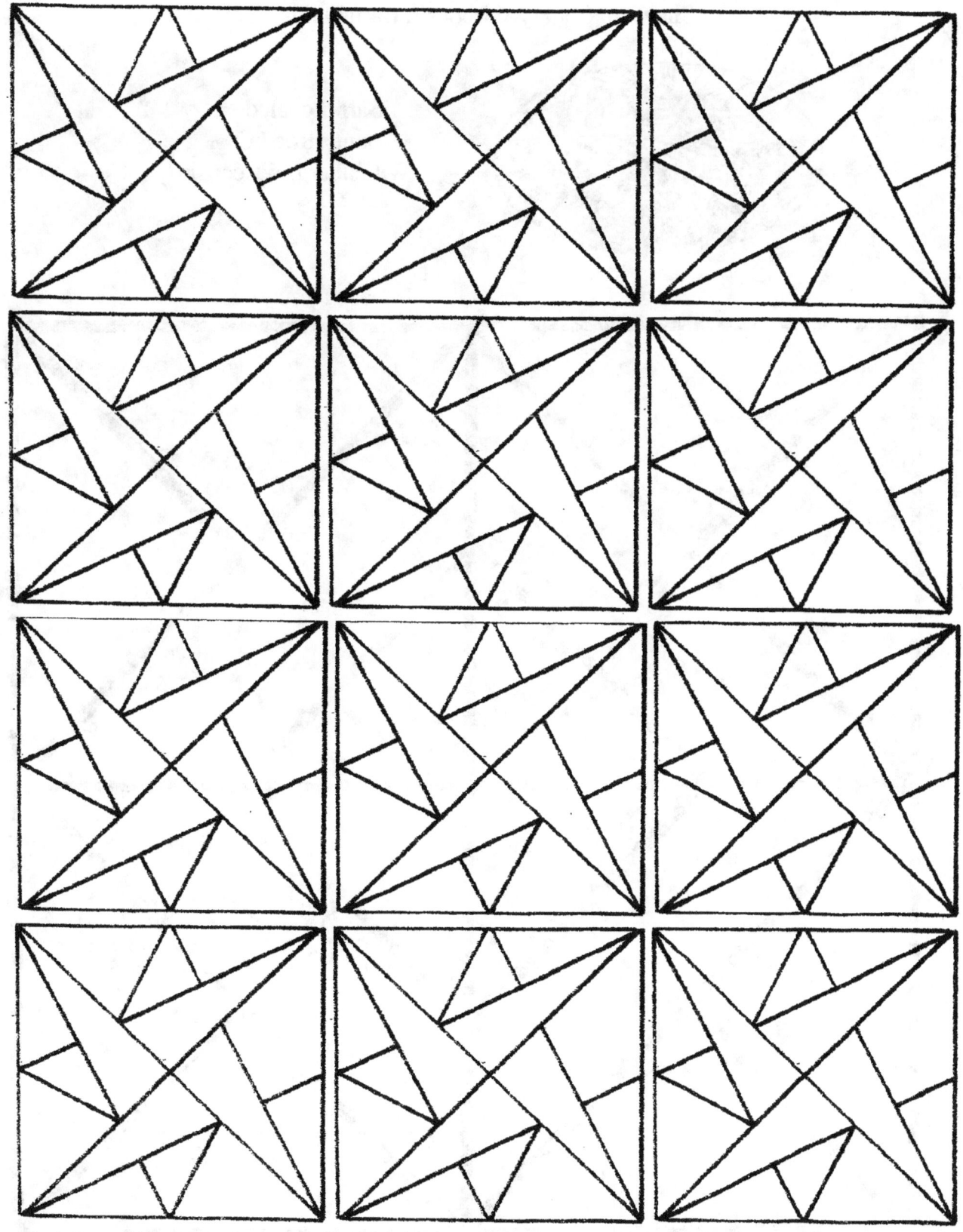

Barn Quilt Whirlygig
Shawano County Wisconsin Barn Quilts

Barn Located
County Road Q
Wittenberg, Wisconsin

Wisconsin Barn Quilt Whirlygig

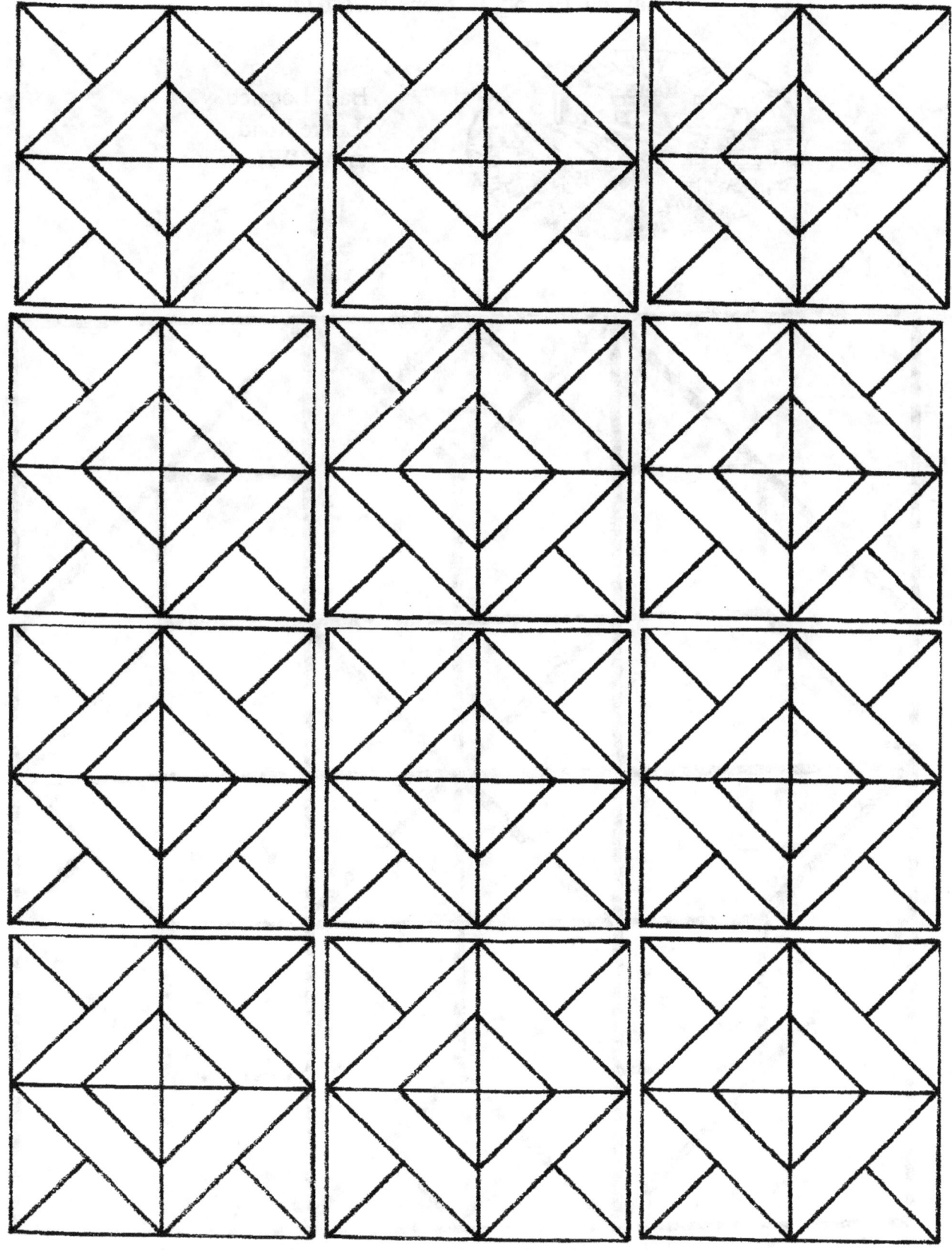

Barn Quilt Evening's Last
Shawano County Wisconsin Barn Quilts

Barn Located
Linke Road
Tigerton, Wisconsin

Wisconsin Barn Quilt Evening's Last

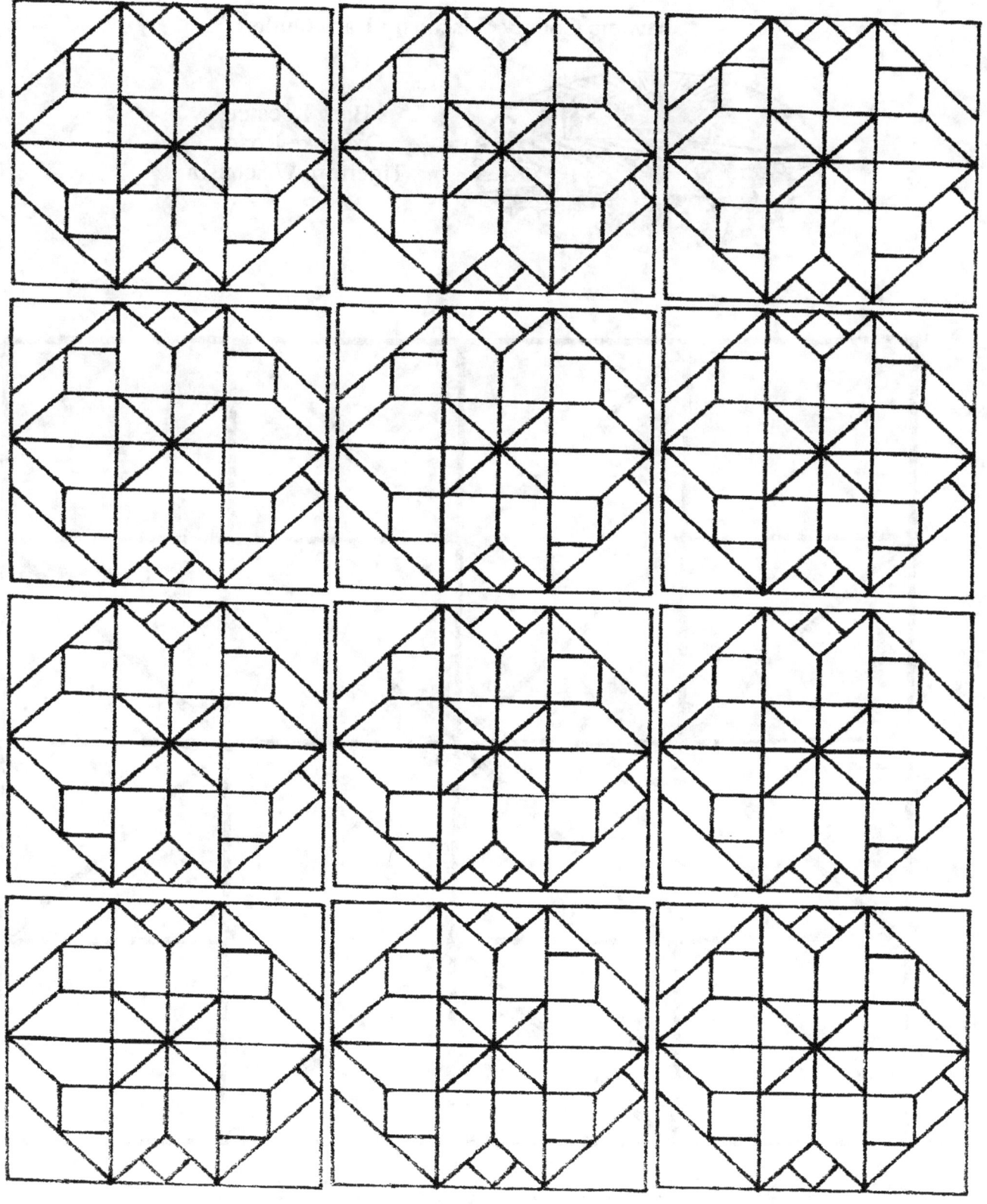

Barn Quilt Twinkling Star
Shawano County Wisconsin Barn Quilts

**Barn Located
Ox Yoke Road
Tigerton, Wisconsin**

Wisconsin Barn Quilt Twinkling Star

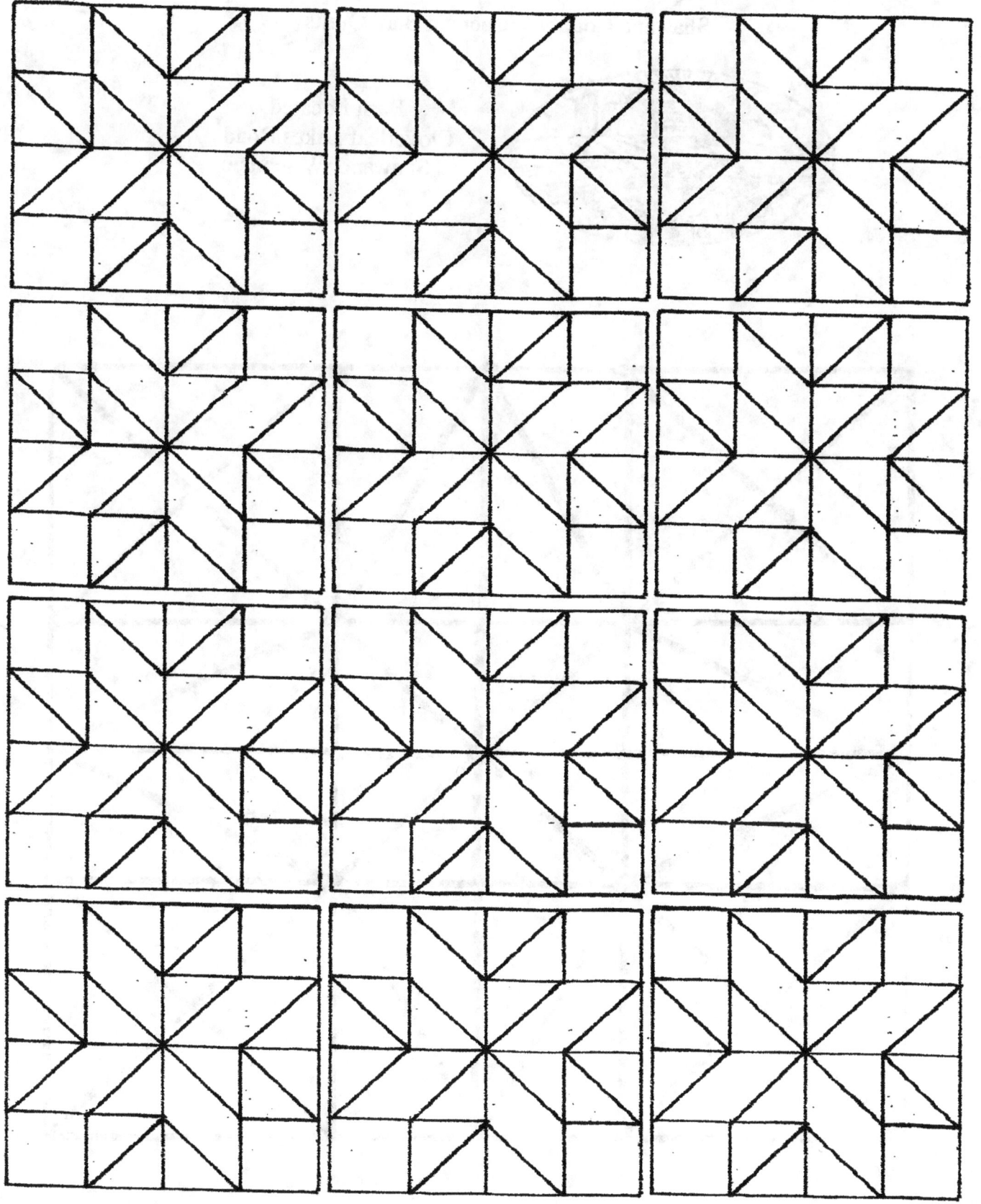

Barn Quilt Optical Illusion
Shawano County Wisconsin Barn Quilts

Barn Located
Cloverleaf Lakes Road
Shawano, Wisconsin

Wisconsin Barn Quilt Optical Illusion

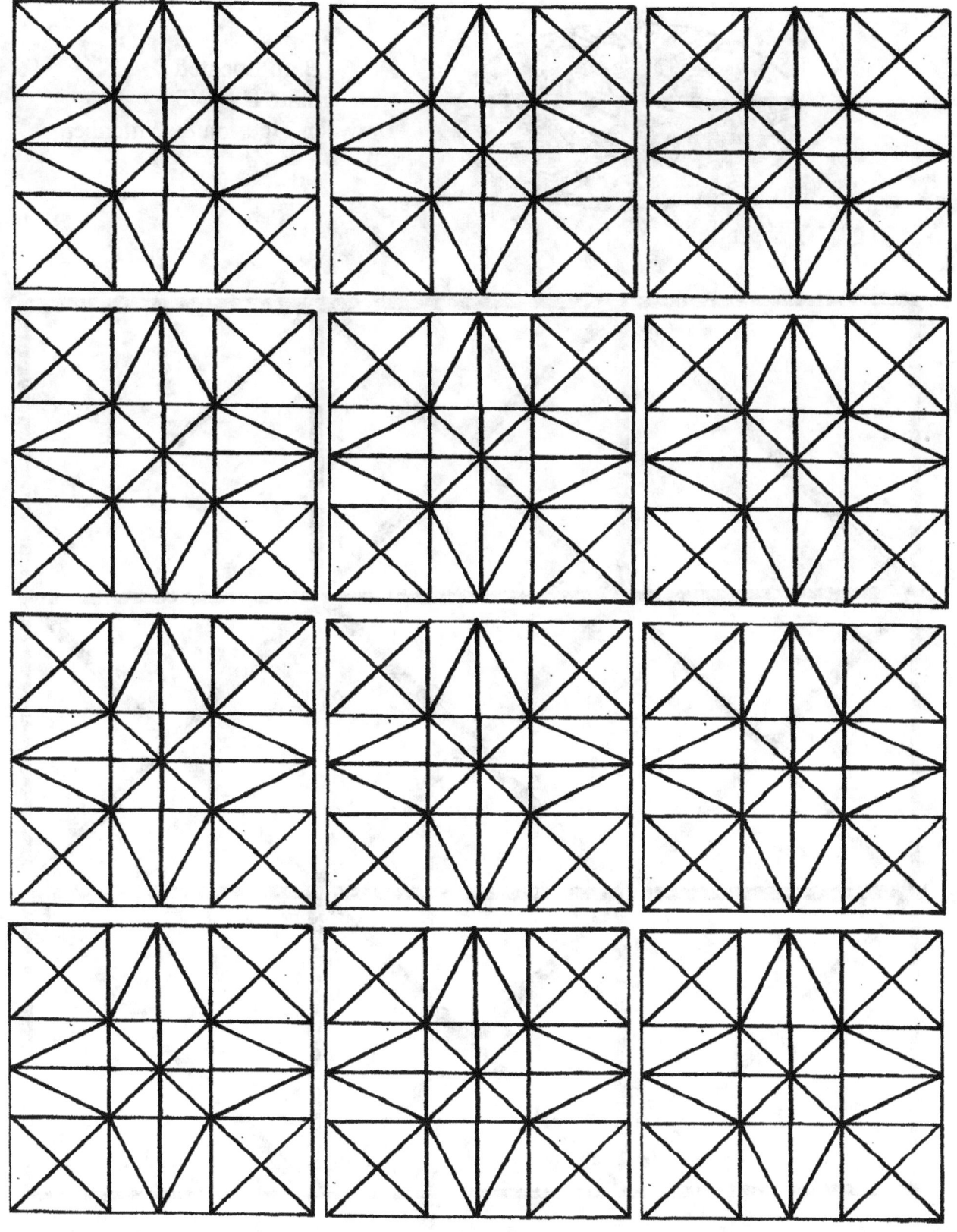

Barn Quilt Butterfly Stars
Shawano County Wisconsin Barn Quilts

Barn Located
State Hwy 45
Between Tigerton & Wittenberg

Wisconsin Barn Quilt Butterfly Star

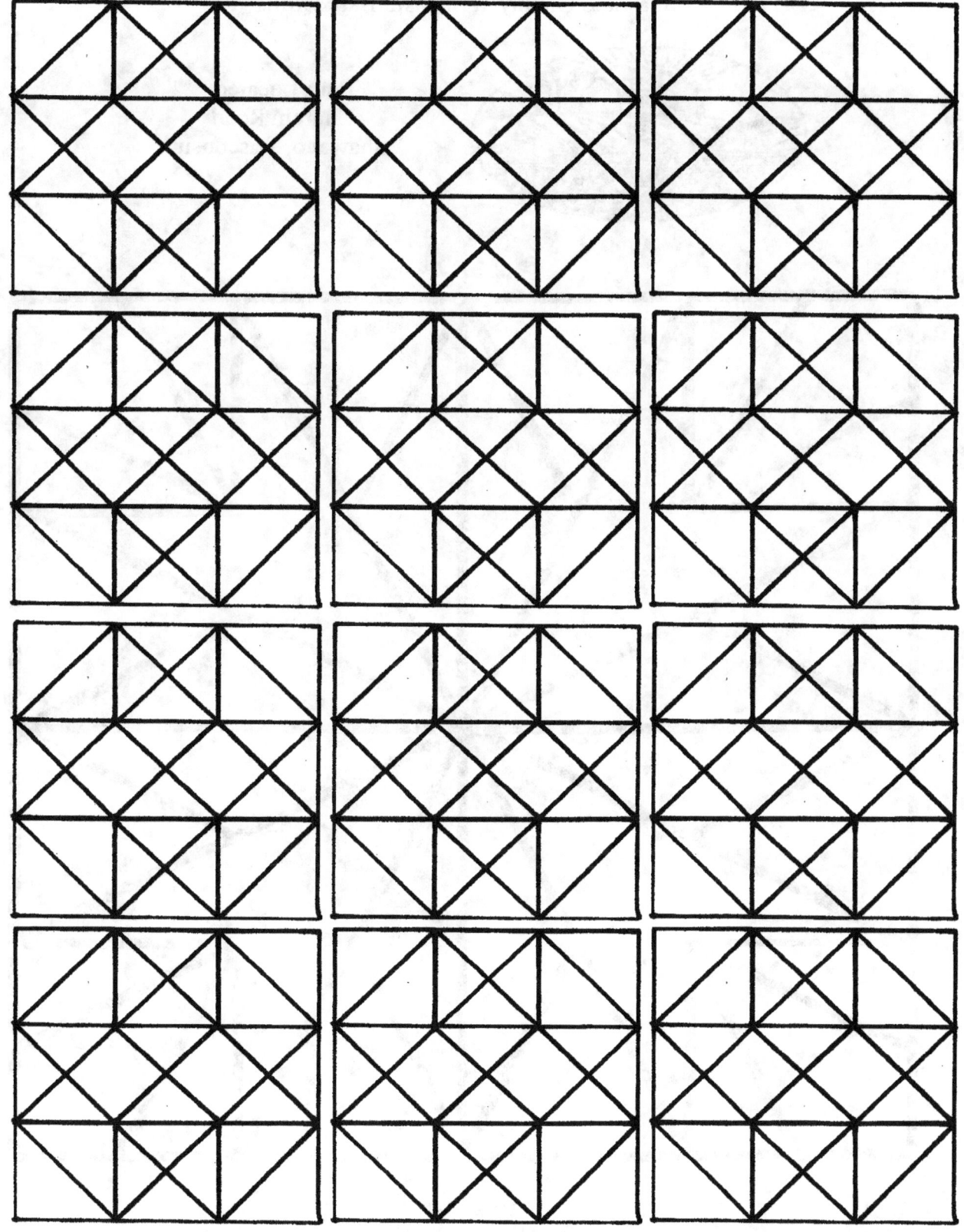

Barn Quilt Welcome Home
Shawano County Wisconsin Barn Quilts

Barn Located
Church Road
Shawano, Wisconsin

Wisconsin Barn Quilt Welcome Home

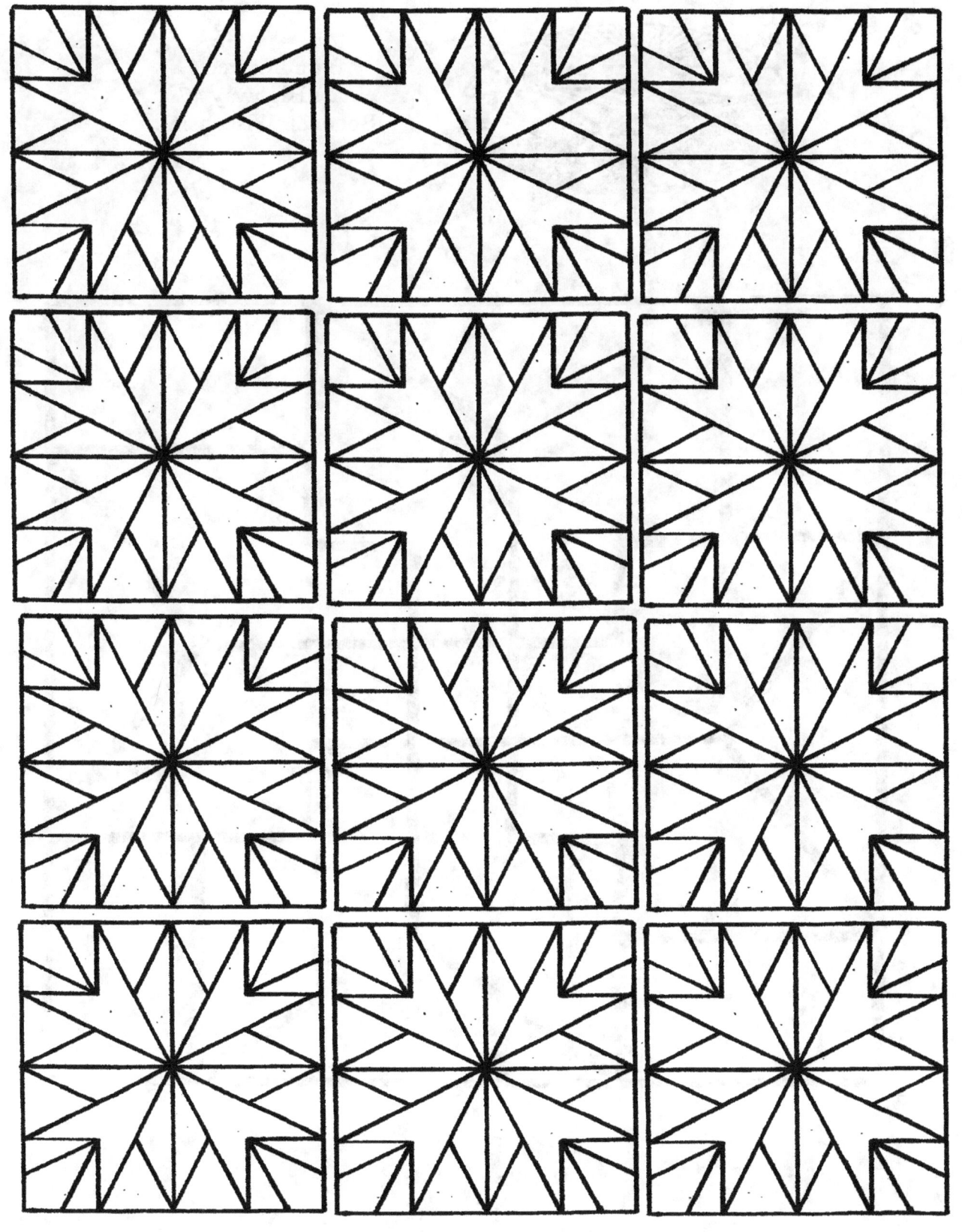

Barn Quilt Nebraska Windmill
Shawano County Wisconsin Barn Quilts

Barn Located
State Highway 47
Bonduel, Wisconsin

Wisconsin Barn Quilt Nebraska Windmill

Barn Quilt Road to Damascus
Shawano County Wisconsin Barn Quilts

Barn Located
Old Dump Road
Bonduel, Wisconsin

Wisconsin Barn Quilt Road to Damascus

Barn Quilt Endless Ribbon
Shawano County Wisconsin Barn Quilts

Barn Located
Brook Road
Shawano, Wisconsin

Wisconsin Barn Quilt Endless Ribbon

Barn Quilt All American Star

Shawano County Wisconsin Barn Quilts

Barn Located
County Road CC
Shawano, Wisconsin

Wisconsin Barn Quilt All American Star

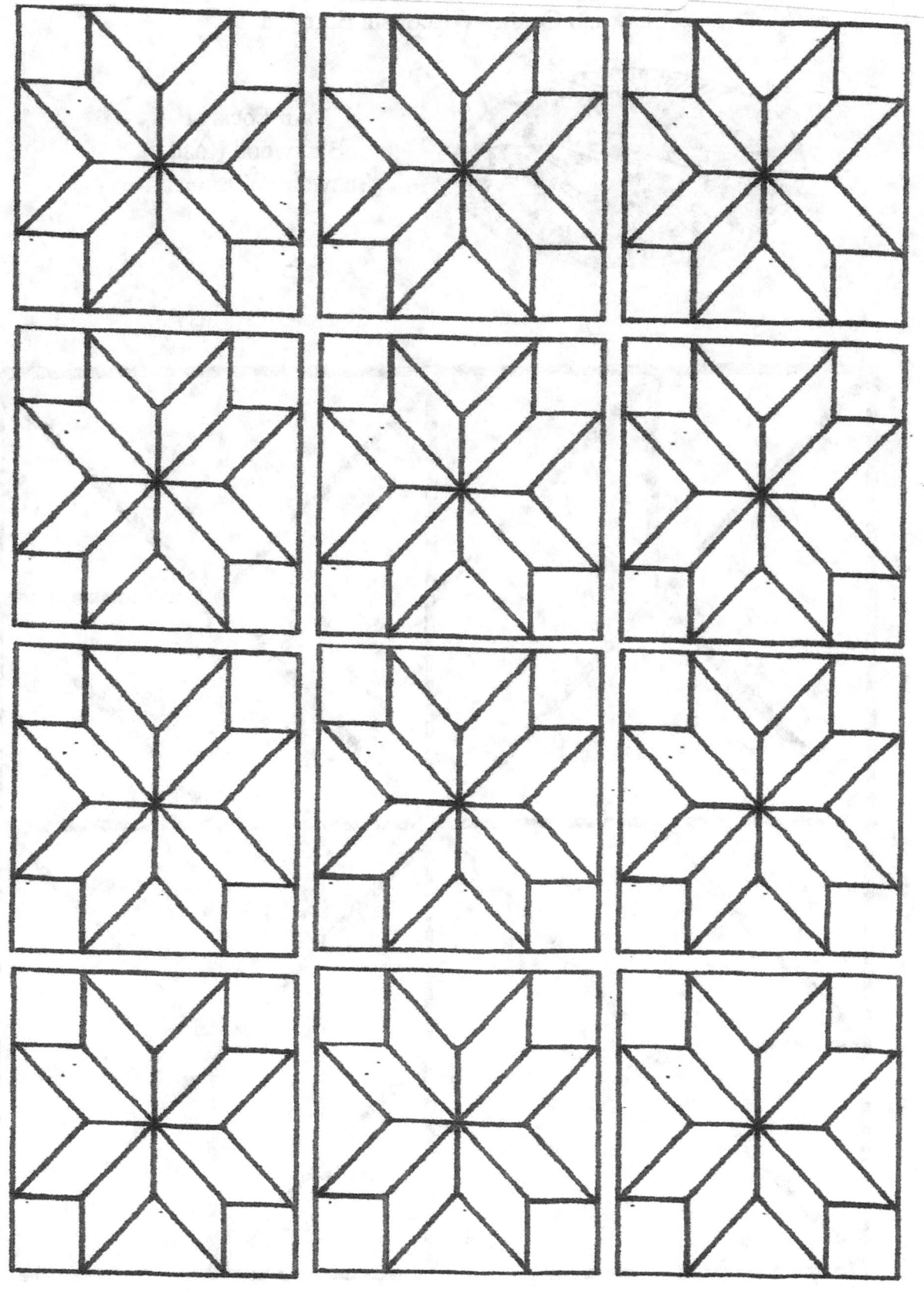

Barn Quilt Spinning Star
Shawano County Wisconsin Barn Quilts

Barn Located
Basswood Road
Shawano, Wisconsin

Wisconsin Barn Quilt Spinning Star

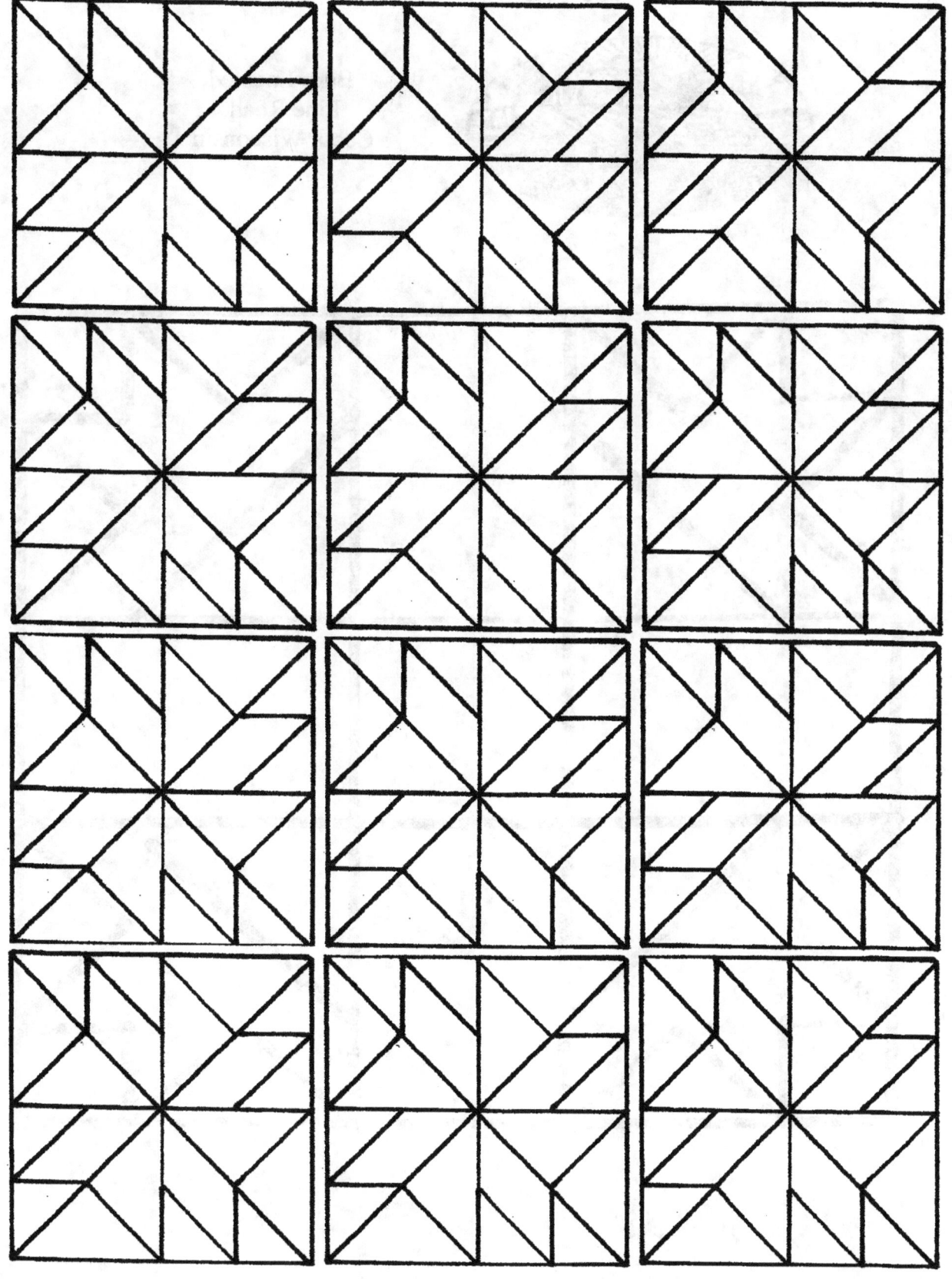

Barn Quilt Pieced Tulips
Shawano County Wisconsin Barn Quilts

Barn Located
Pine Road
Cecil, Wisconsin

Wisconsin Barn Quilt Pieced Tulips

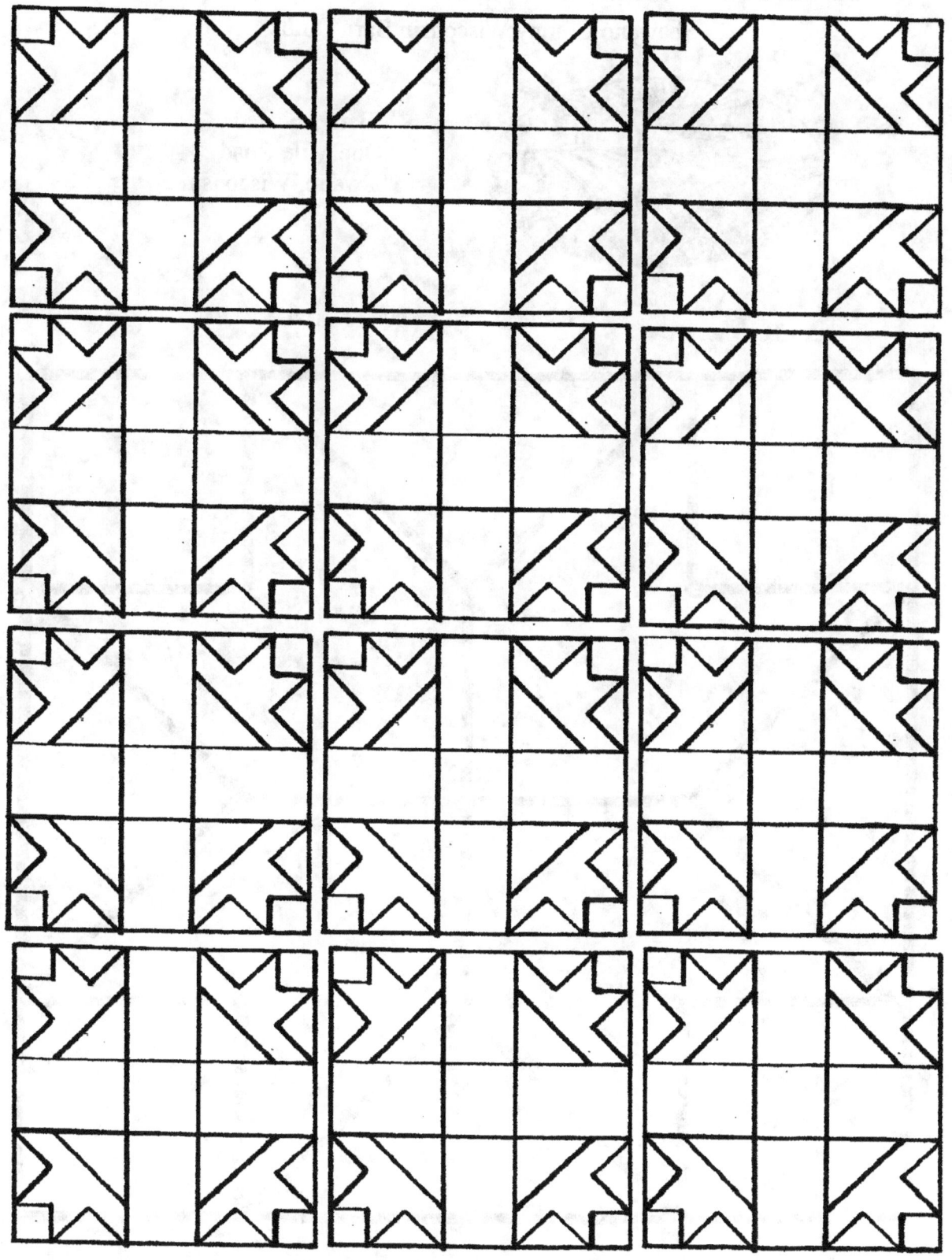

Barn Quilt Eight Pointed Star
Shawano County Wisconsin Barn Quilts

Barn Located
One Mile Road
Shawano, Wisconsin

Wisconsin Barn Quilt Eight Pointed Star

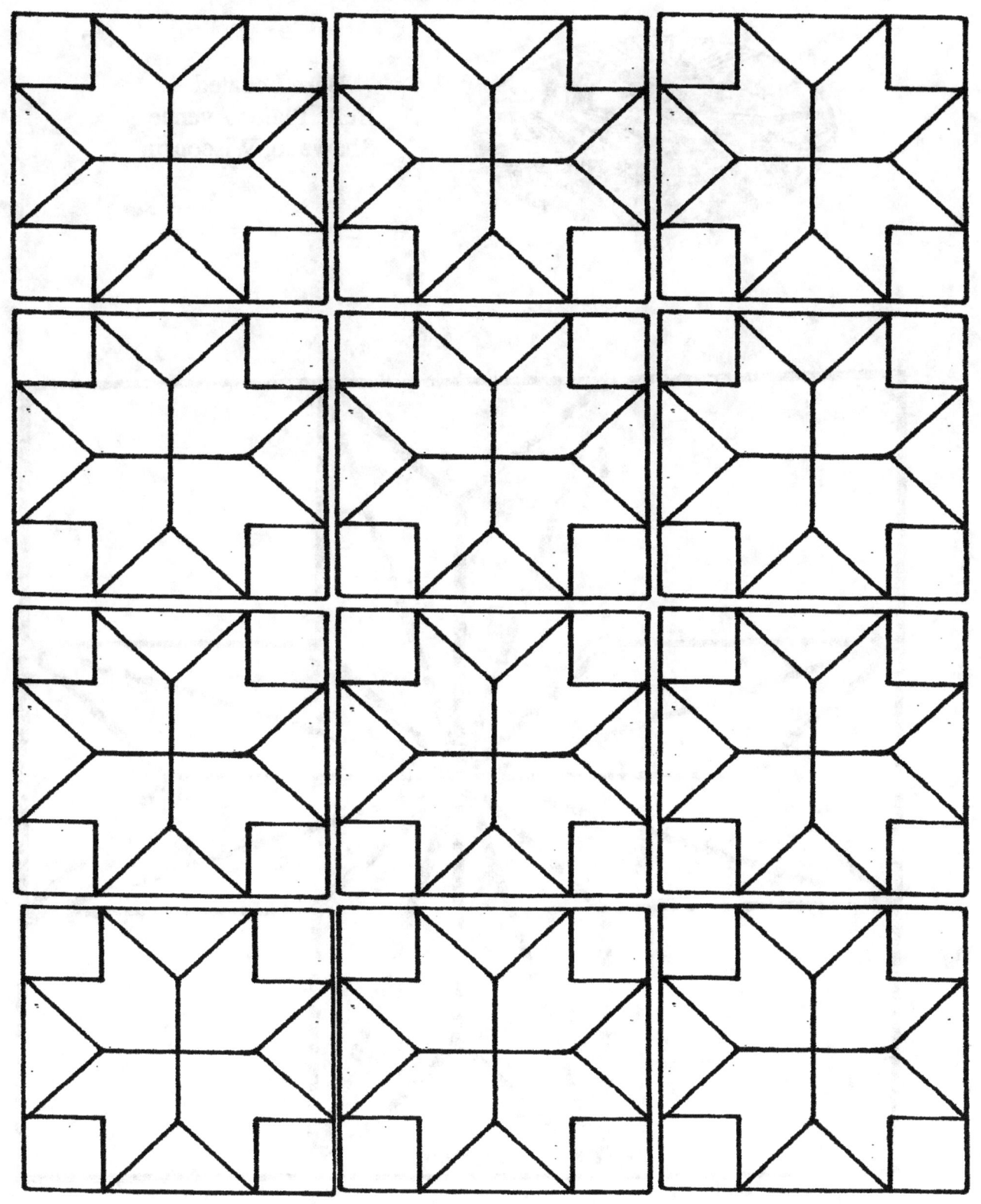

Barn Quilt LeMoyne
Shawano County Wisconsin Barn Quilts

**Barn Located
Belle Plaine Avenue
Shawano, Wisconsin**

Wisconsin Barn Quilt Le Moyne

Barn Quilt Star Within a Star
Shawano County Wisconsin Barn Quilts

Barn Located
Curt Black Road
Shawano, Wisconsin

Wisconsin Barn Quilt Star Within a Star

Barn Quilt Sunflower
Shawano County Wisconsin Barn Quilts

Barn Located
Locust Road
Shawano, Wisconsin

Wisconsin Barn Quilt Sunflower

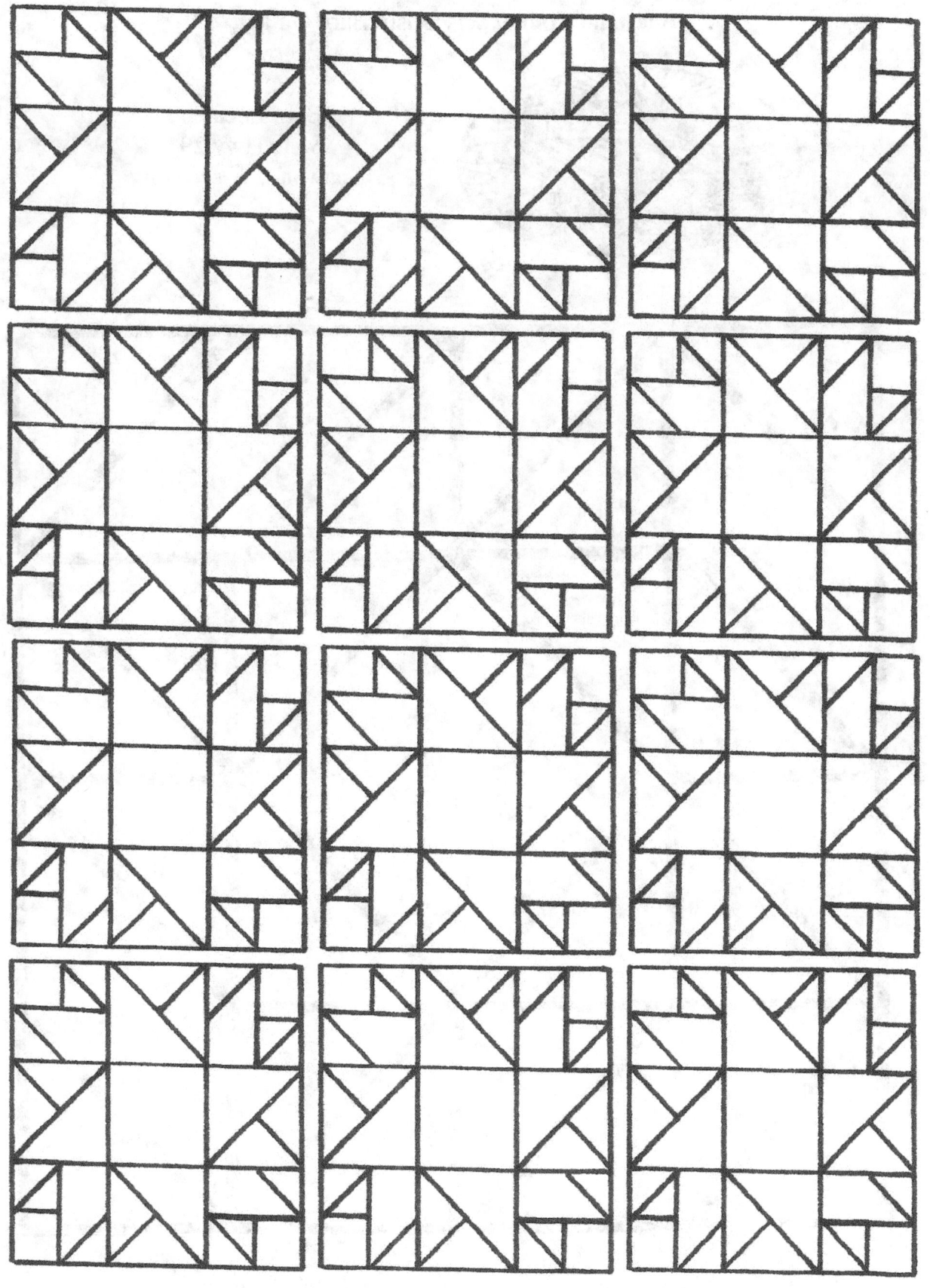

Barn Quilt Saw Tooth Square

Shawano County Wisconsin Barn Quilts

Barn Located
State Hwy 29
Shawano, Wisconsin

Wisconsin Barn Quilt Saw Tooth Square

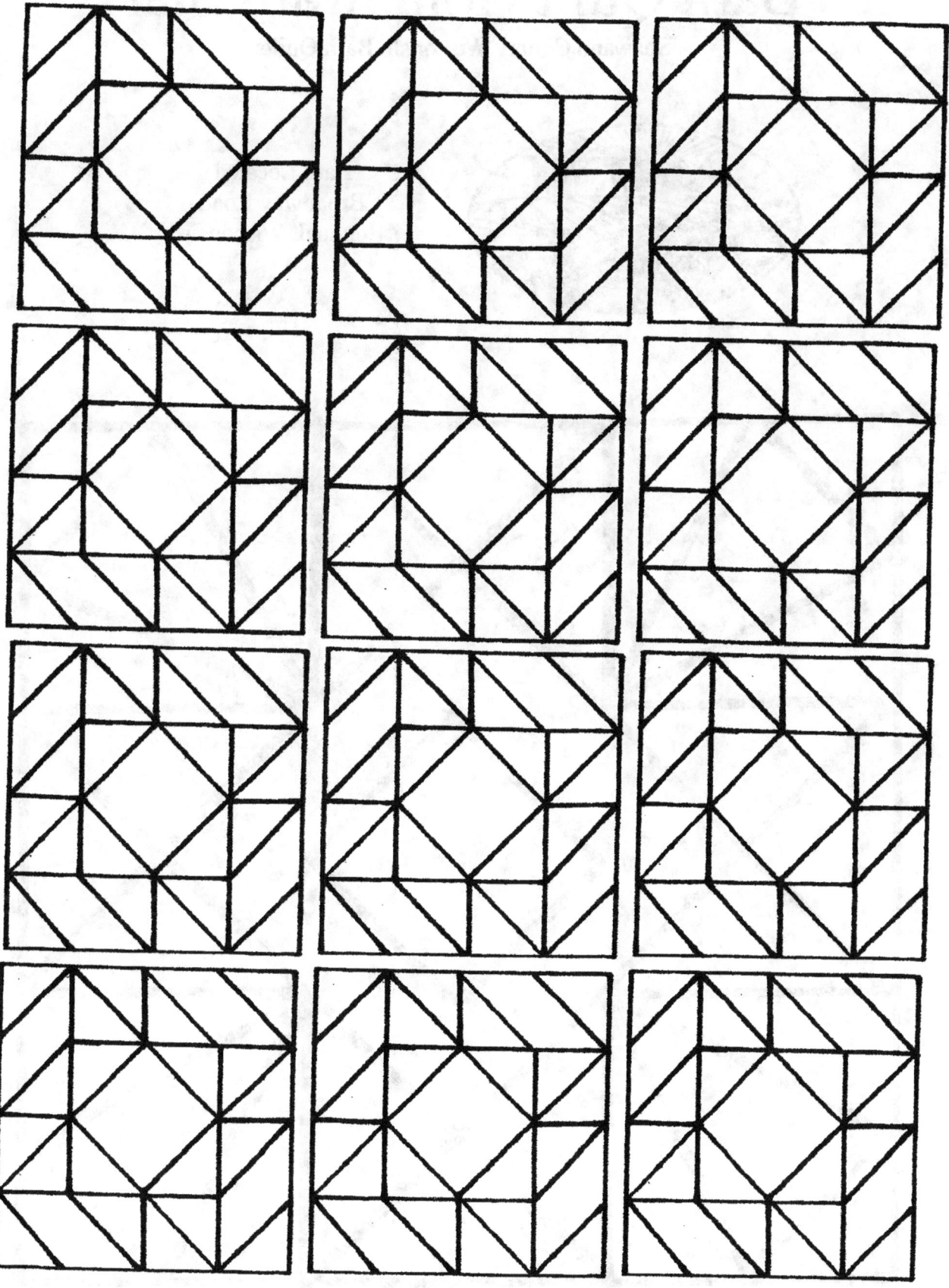

Barn Quilt Homeward Star
Shawano County Wisconsin Barn Quilts

Barn Located
Broadway Road
Bonduel, Wisconsin

Wisconsin Barn Quilt Homeward Star

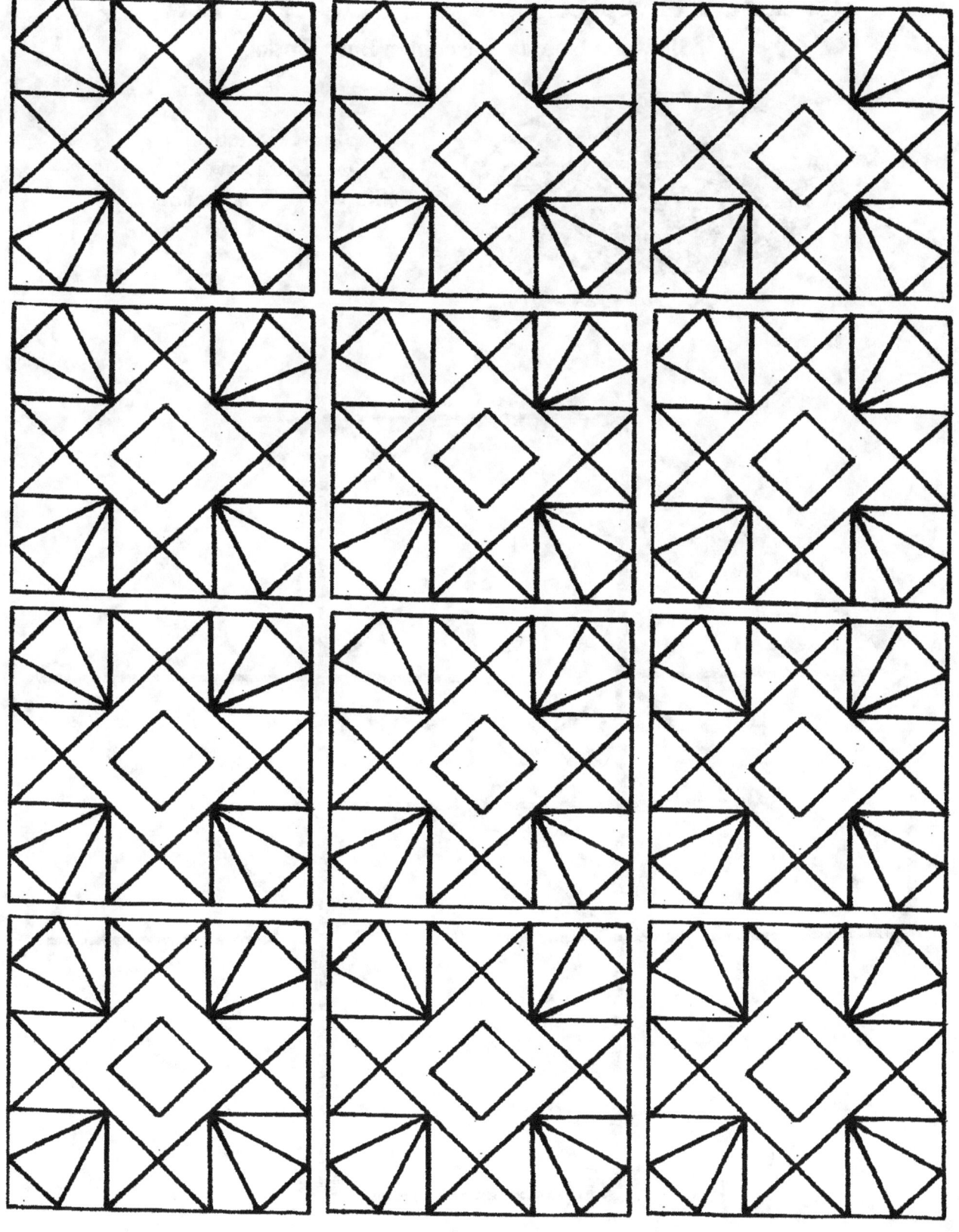

Barn Quilt Pierced Star
Shawano County Wisconsin Barn Quilts

Barn Located
Oakcrest Drive
Shawano, Wisconsin

Wisconsin Barn Quilt Pierced Star

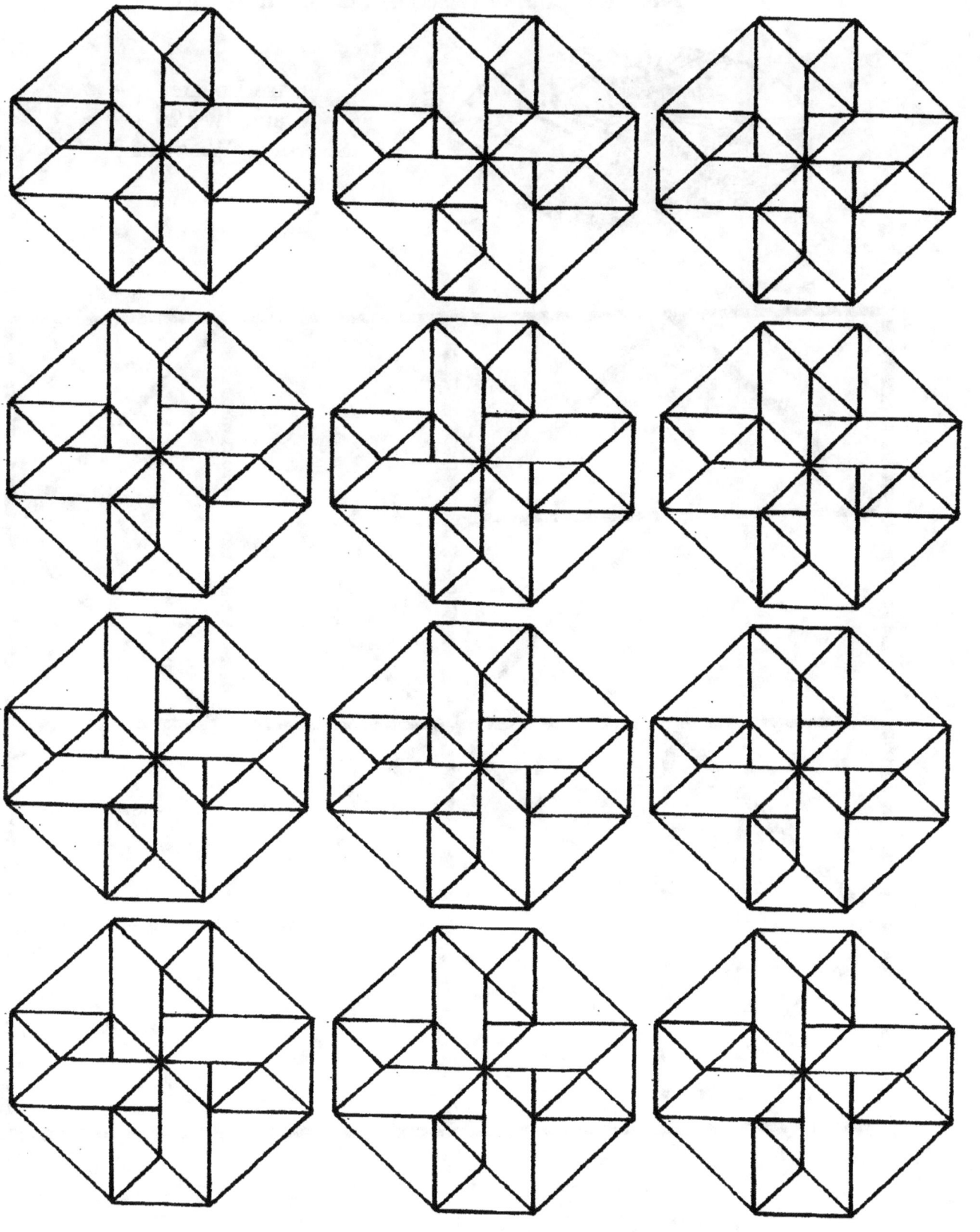

Barn Quilt Saw Electric Fan

Shawano County Wisconsin Barn Quilts

Barn Located
State Hwy 29
Shawano, Wisconsin

Wisconsin Barn Quilt Electric Fan

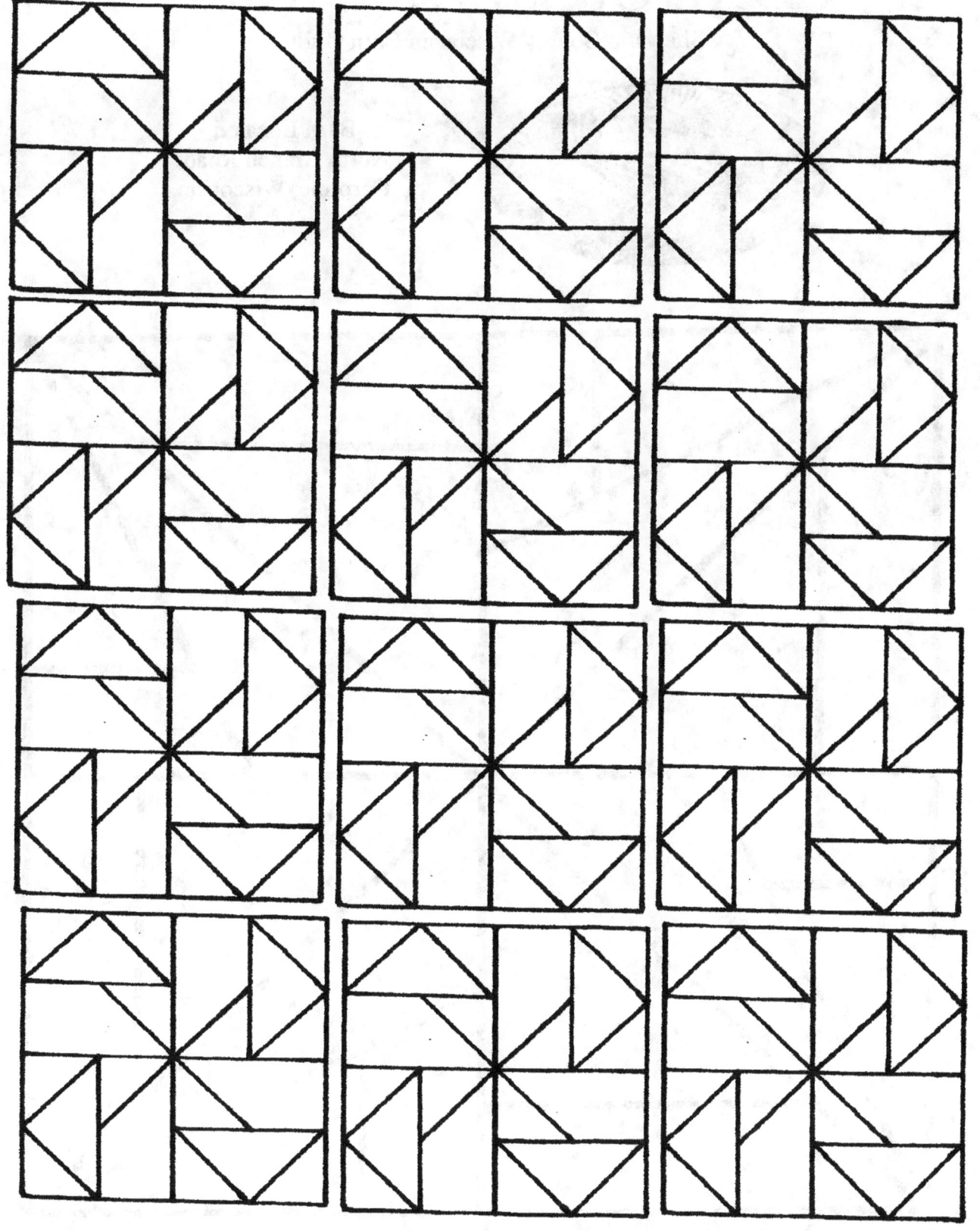

Barn Quilt Flying Kites
Shawano County Wisconsin Barn Quilts

**Barn Located
North Branch Road
Caroline, Wisconsin**

Wisconsin Barn Quilt Flying Kites

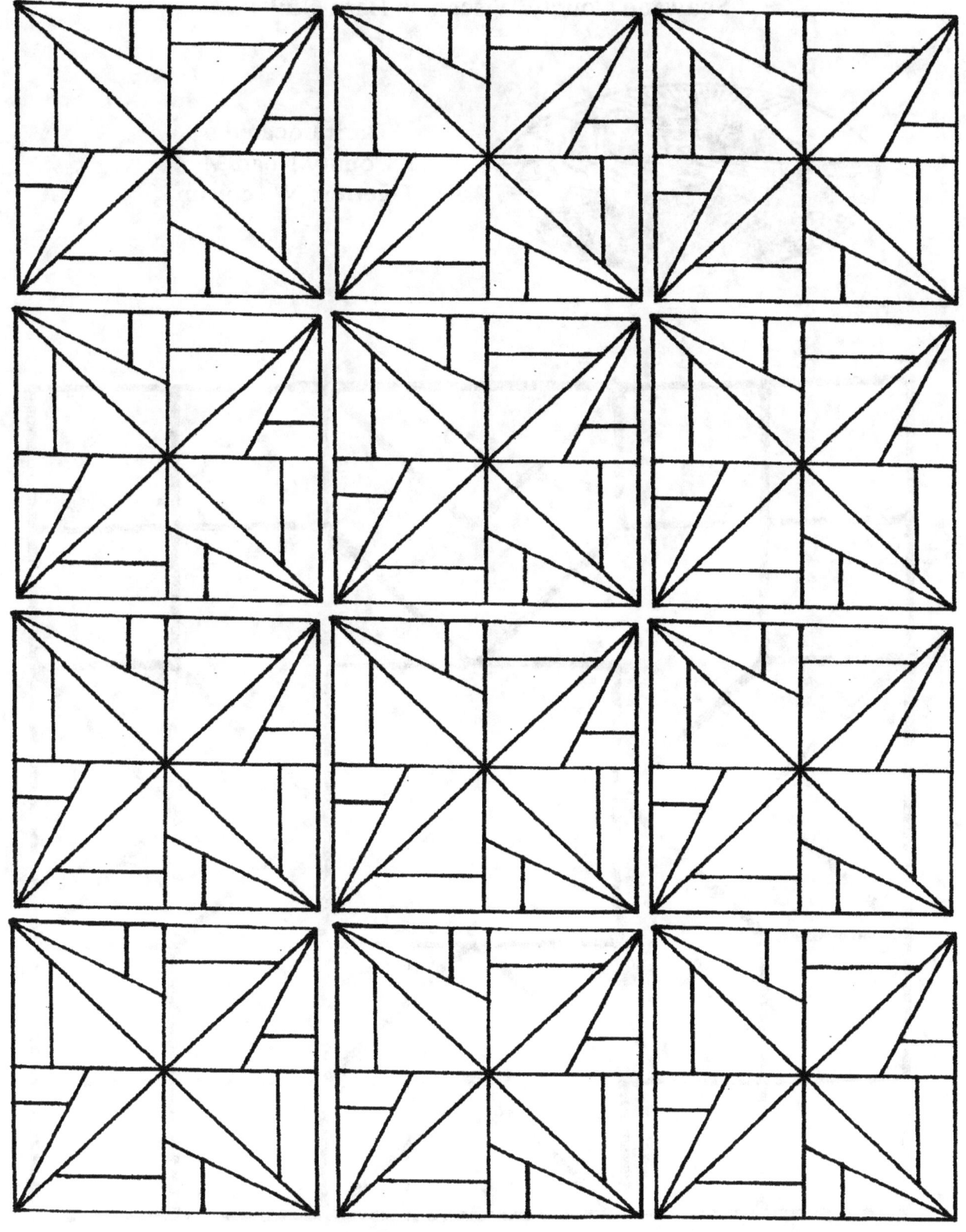

Barn Quilt Merry Kite
Shawano County Wisconsin Barn Quilts

**Barn Located
County Road M
Tigerton, Wisconsin**

Wisconsin Barn Quilt Merry Kite

Barn Quilt Southern Star
Shawano County Wisconsin Barn Quilts

Barn Located
Hazel Drive
Shawano, Wisconsin

Wisconsin Barn Quilt Southern Star

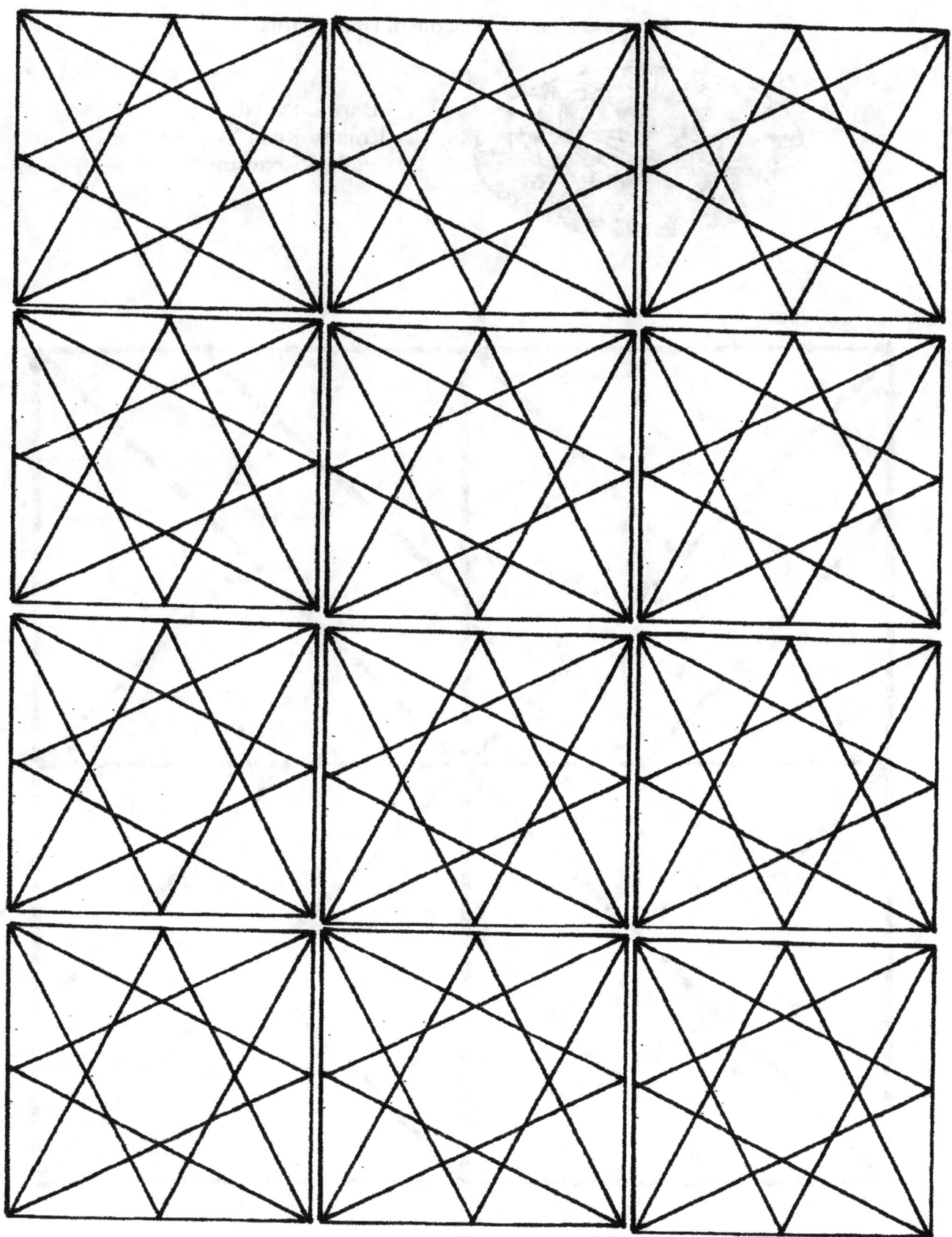

Barn Quilt Four Patch Pinwheel
Shawano County Wisconsin Barn Quilts

Barn Located
County Road V
Cecil, Wisconsin

Wisconsin Barn Quilt Four Patch Pinwheel

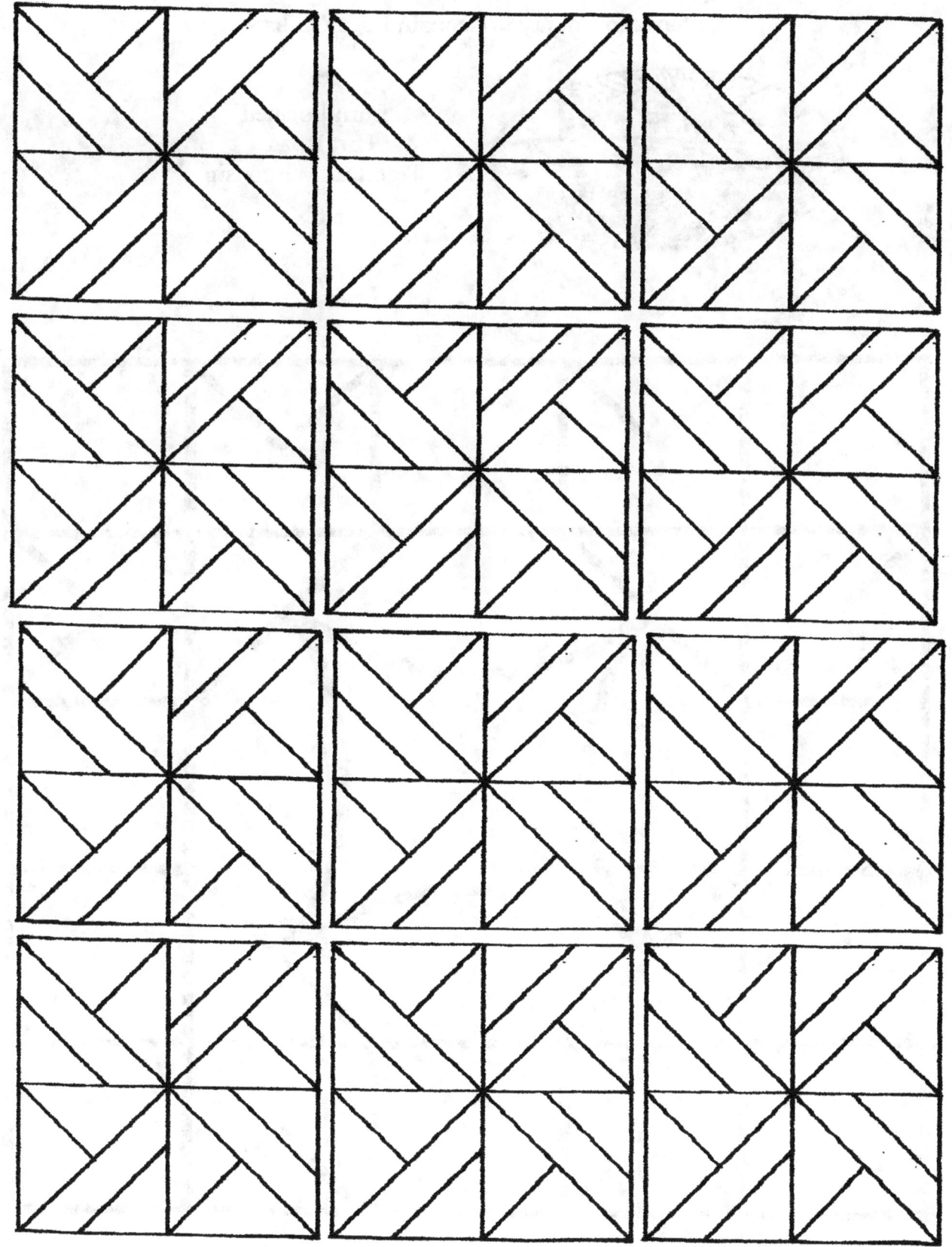

Barn Quilt Hands All Around
Shawano County Wisconsin Barn Quilts

Barn Located
Hirt Road
Tigerton, Wisconsin

Wisconsin Barn Quilt Hands All Around

Barn Quilt Seesaw
Shawano County Wisconsin Barn Quilts

**Barn Located
Stony Hill Road
Marion, Wisconsin**

Wisconsin Barn Quilt Seesaw

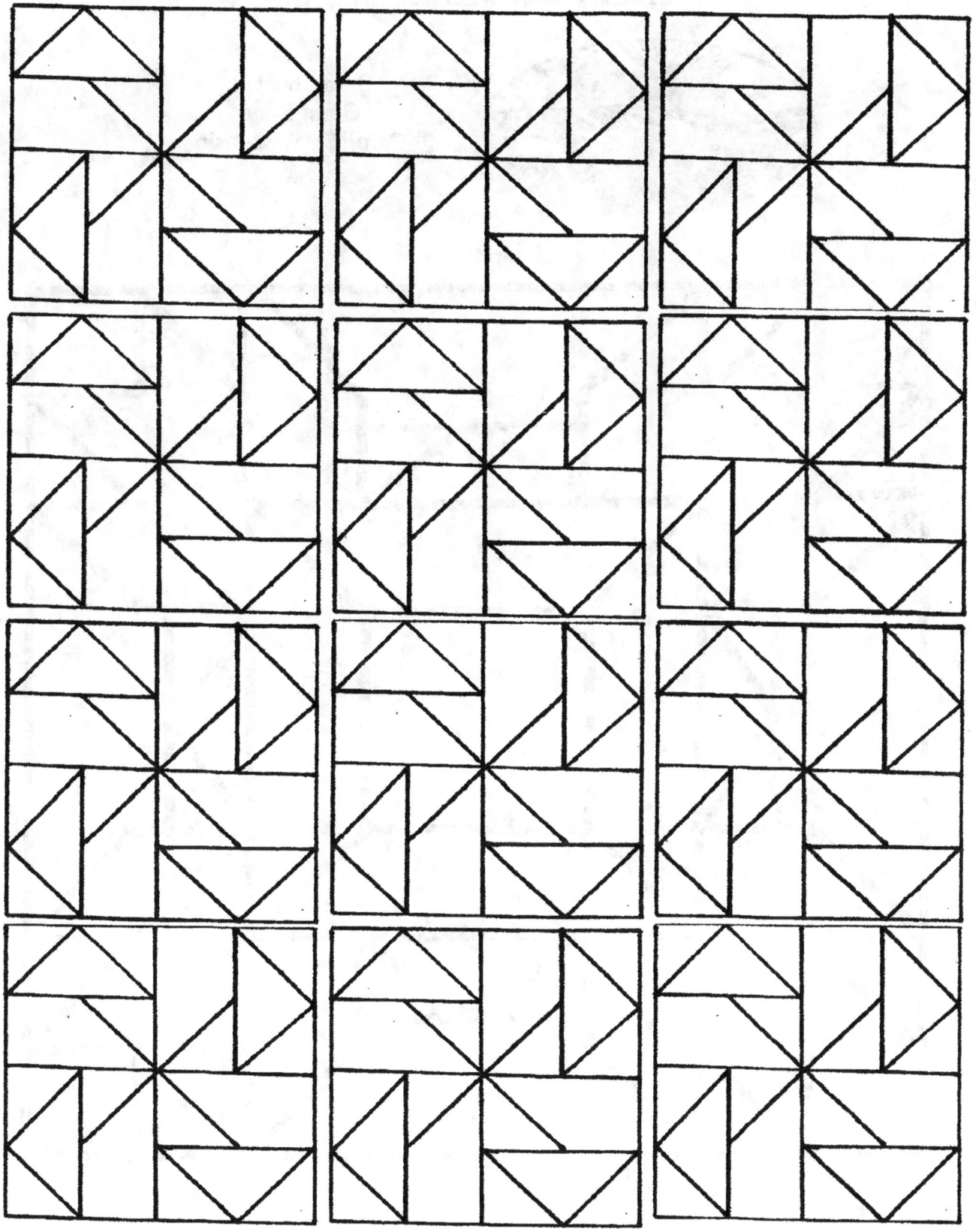

Barn Quilt Autumn Leaves
Shawano County Wisconsin Barn Quilts

Barn Located
Grant Road
Caroline, Wisconsin

Wisconsin Barn Quilt Autumn Leaves

Barn Quilt Twisted Star
Shawano County Wisconsin Barn Quilts

Barn Located
Oak Avenue
Shawano, Wisconsin

Wisconsin Barn Quilt Twisted Star

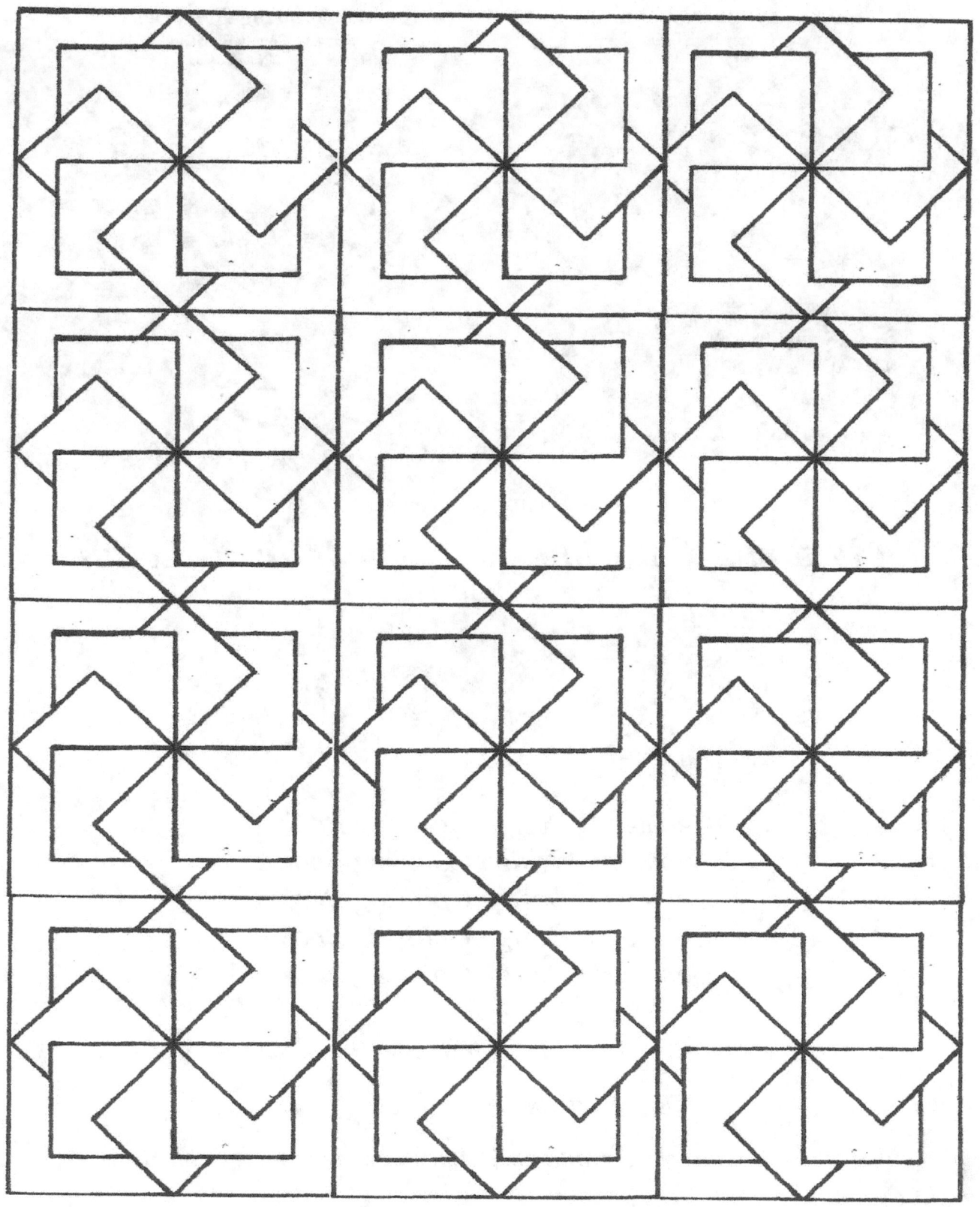

New Coloring Books by John H. Lettau

Wisconsin Barn Quilts
Coloring Book One
Shawano County Barn Quilt Project
John H. Lettau

48 Barn Quilts included in the Shawano County Barn Quilt Project

Wisconsin Barn Quilt
Coloring Book Two
Shawano County Barn Quilt Project
John H. Lettau

48 Barn Quilts included in the Shawano County Barn Quilt Project

Additional Coloring Books by John H. Lettau

 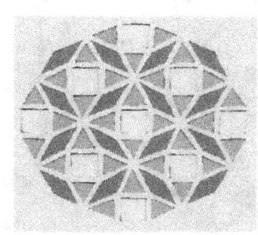

Geometric Design Coloring Book 1
Geometric Design Coloring Book 2
Geometric Design Coloring Book 3
Geometric Design Coloring Book 4
Geometric Design Coloring Book 5

Also create your own barn quilt patterns with...Graph Paper Designs

Coloring Books as Stress Therapy...Try it!!!

All John Lettau books are available at Amazon.com...google John H. Lettau

www.ingramcontent.com/pod-product-compliance
Lightning Source LLC
Chambersburg PA
CBHW081203180526
45170CB00006B/2194